& Rations

The Postcards of Leo Sidebottom
Company 351 British Expeditionary
Force France WW1

AuthorHouse™
1663 Liberty Drive
Bloomington, IN 47403
www.authorhouse.com
Phone: 1-800-839-8640

Published by AuthorHouse 10/01/2012

ISBN: 978-1-4567-8789-9 (sc)
ISBN: 978-1-4567-8790-5 (hc)
ISBN: 978-1-4567-8791-2 (e)

Dedication

To all the people who helped with this especially, Flora, my daughter, for her undying enthusiasm for the project, Virginie for her patience, all the friends who helped along the way (you know who you are), and John and Paul at "Where Art now" for the cover.

Preface

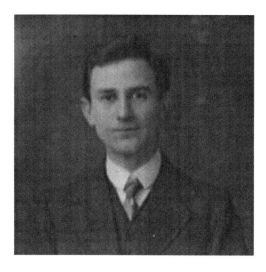

Leo Sidebottom was born in Chorley, Lancashire in 1890. His father was a mining engineer and author of "Sections of the Yorkshire Coal Fields". It is said that he invested his money in a mining venture which collapsed so he came to Birmingham. The city had a great reputation as the "workshop of the world" after the successes of Priestly, Boulton and Watt, consequently there was a great demand for engineers.

Whilst living in Rotten Park Road, in what is now Edgbaston, he met Annie in 1909 who lived in the same road, it was a case of love at first sight, and they married just before he left for the trenches of France to play his part in the 1st World War. They were happily married until his death in 1974. As a child I remember him as a kind and gentle grandfather, a quiet man with great morals and a committed Christian although he had stopped attending church apart from special occasions. You will find many references in this book to church and religious services, these served as a form of normality and also to remind him of home. Faith probably played a big part in the resolve of the participants in this war which presented such horrors. He walked everywhere despite having one

leg longer than the other. He also had a moustache which he grew to cover up a shrapnel scar incurred during his time in action in France.

We used to collect stamps together, but my enduring memory of him is of all the poppies we made for the British Legion Remembrance Sunday collections, emptying the collecting tins when they were returned, and counting the money he had collected. He and Annie were often invited to the garden parties at Buckingham Palace in reward for his tireless efforts collecting for the British Legion every year.

Leo worked as a clerk at Tangyes, a Birmingham firm set up by two brothers from Cornwall who manufactured amongst other engineered products pumps, hence Leo's joining the Royal engineers land drainage section, allowing him to get some experience before setting off for war. Tangyes still supply engineering equipment today. Run by Quakers (much like the Cadburys) Tangyes pioneered better working conditions for their workers. It was in 1856 that the great engineer Isambard Kingdom Brunel built the massive "S.S. Great Eastern" which was until then the largest ship ever constructed, only to experience great difficulty in launching the vessel. It was the Tangye brothers who came to his aid and launched the vessel by providing powerful hydraulic jacks for the task. Hence the term "Tangyes launched the Great Eastern and the Great Eastern launched Tangyes".

When he returned from France in 1919 he returned to Tangyes to the job he had left behind, until 1929 (the great depression) when he had to find alternative employment. He then worked for the General Electric Company until he retired in 1958. After that he looked after my elder sister and myself until he found this too taxing, so went back to work for a small engineering company as a French correspondent using the French he had acquired during the war.

One day in 1974 after walking the dog he was taken to hospital with cancer and died later that day. Annie never worked; she had only one child, my father John, born in 1927. Annie never recovered from Leo's death and died of a broken heart a few years later.

I hope you enjoy this book, it has come about almost by accident, the postcards found mixed up with many others in a suitcase in the loft. It is not sensational, just an average man's view of the world from an extraordinary situation. In many cases it seems he focuses on what is happening at home in order to avoid the horrors of the place he was in and many of the postcards are cryptic as the rules on what you could say were very strict with harsh penalties. The format consists of the postcard followed by the text which was written on the back.

I hope you enjoy these words, pictures and experiences.

Nic Sidebottom.

Persons mentioned in this book:

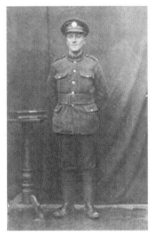

Leo, *(rear centre in photograph below)*; **Anne-Marie,** his wife, also called Chummie; Lassie, Little one, **Eric & Alan,** Leo's older brothers who was already enlisted and fighting in France, *(rear left and rear right in photograph below)*; **Ilma,** Leo's younger sister, *(front left in photograph below)*; **Percy,** his friend with whom he enlisted (photograph left taken 1915); **Dad at 97,** Annie's father, **Alice,** a French woman Leo was billeted with.

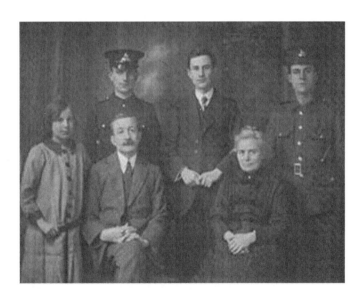

Diary.

The following pages from Leo's diary take us through the days of enlisting, getting married and leaving for war!

Tuesday 26th October 1915

Got up at 7. At work Percy Quarce mentioned a special section of the Royal Engineers (Land drainage section). We went to Mr Parkins & he gladly consented for us (after seeing Mr Roberts) to come in at 6am tomorrow into the oil engine shop to learn to drive oil engines. Enlistments on Friday next. At home read a little. Went up to Butlers (girlfriends). Told Annie (on way to library where I withdrew ticket) that I should enlist on Friday. She was speechless. Not a word all night.

Bed 11-0

Wednesday 27th October 1915

Got up at 5-10. In oil engine shop by 6am; Percy a little later. Mr Sanders started a 10BPoil on Magneto ignition. We did it & ran it & stopped it. From remarks of a chap in shop we understand that there is no need to wait until Friday so after breakfast we enlisted at James Watt St. in Royal Engineers (Land Drainage Co.) as eng drivers (oil) at 3\– (shillings)day. Back to Tangyes, obtained permit to enlist. Sworn in at 6pm receiving 4\9 (1st days pay) I called at Samuel Hopes, Vyse St & saw Miss Smith about an engagement ring. Told Annie and Dad about it all when I found them at home. Annie made me feel despairing—she was perfectly cold.

Bed 11-0

Thursday 28th October 1915

Got up at 5-10. In shops by 6-20. We made very good progress all day on engines—Started 13BP on blow lamp. Later started 3½BP on blowlamp and later cleaned 3½BP taking out piston & valves etc. Put them back in afternoon & started her up allright. Left at 4.30. Met Annie in town at 5pm went to J. B. Clarkes & arranged about special licence which as a special favour will be ready at 12 noon tomorrow. Then to Samuel hopes where we saw Miss Smith and obtained wedding ring. Then home, wrote Eric, Alan (brothers already enlisted) George, also finished a letter to Jack Bishton. Went up to Annie and arranged with Vicar for 2pm tomorrow. Round to Butlers & broke the news. Round to choir meeting then home. Broke news there. All four parents were very nice about it.

Bed 11-0

Friday 29th October 1915-My Wedding Day

Glorious Sunshine! Got up at 5.30. In shops by 6.20. worked away till breakfast. From 9.10 to 12.15 I was saying "adieu"—had very fine half hour with Mr Parkins. Told a few chums about this afternoon. Left at 12-20. Everybody most warm hearted—but then Nov 19th 1915 would have completed 10 years at Tangyes for me. At home shaved and had bath. Alan arrived at 1-30. Eric also being at Coaford is unable to be present today. At church by 1-55 after buying a few flowers on way. Wedding service commenced at 2-0. I was married by vicar to my sweet and tender girl whom I have loved sincerely since Sept 1909 & for whose sake I hope to combat the temptation that I am sure to meet ere long. After tea I wrote postcards to Kidder etc. Went to pictures for honeymoon. Round to Davies's, then to Butlers, down to Matthews. Had present (a little clock) and several wires.

Bed 12-15

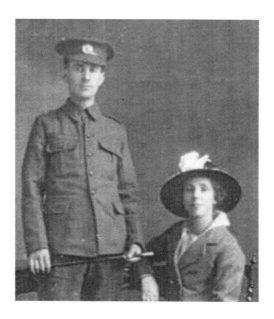

Leo and Annie on their wedding day.

Chatham

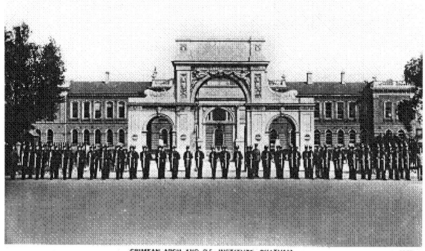

CRIMEAN ARCH AND R.E. INSTITUTE. CHATHAM. 4123

Leo then went to Chatham the next day for training, then to France.

Dearest,

This arch & these men are facing the South African arch which forms entrance Brompton Barracks (R.E.)

Correspondence was limited to postcards such as the one overleaf. This was to limit any intelligence the enemy could acquire should they be captured and also to help with illiteracy.

We then have a break of nearly 2 years when they would have communicated by letter until September 1917, just after Sir John French had been replaced by Sir Douglas Haig and just before the fall of the Russian empire. This was the year the Americans entered the war and the French army mutinied. Both sides were exhausted after the battles of Ypres, the Somme and Marne had conceded little other than heavy casualties.

A Field Postcard

I am quite well.

I have been admitted into hospital

 sick *and am going on well.*

 wounded *and hope to be discharged soon.*

I am being sent down to the base.

I have received your
 letter dated _____
 *telegram ,, * _____
 *parcel ,, * _____

Letter follows at first opportunity.

I have received no letter from you

 lately.

 for a long time.

Signature
only.

Date _____

[Postage must be prepaid on any letter or post card addressed to the sender of this card.]

(92898) Wt. W3497-203 2.2m-m 3.16 J. J. K. & Co., Ltd.

Some background to 1917

1917 saw the Battle of Passchendaele, otherwise known as the Third Battle
of Ypres; this was one of the major battles of World War I, fought by British,
ANZAC and Canadian soldiers against the German army near Ypres (Ieper
in Flemish) in West Flanders, north-western Belgium over the control of the
village of Passchendaele. Leo mentions all the different nationalities of troops he
encounters. As the village is now known as Passendale, the term Passchendaele
alone is now used to refer to this battle. The label "Passchendaele" should
properly apply only to the battle's later actions in October-November 1917, but has
come to be applied also to the entire campaign from July 31. After three months
of fierce fighting, the Canadian Corps took Passchendaele on November 6, 1917,
ending the battle. Passendale today forms part of the community of Zonnebeke,
Belgium.

Messines Ridge

The Messines ridge, just south of Ypres had been lost to the Germans in the first
battle of Ypres, leaving Ypres as a salient, sticking out into the German position
and overlooked by higher ground on the German side. Field Marshal Sir Douglas
Haig, the allied commander, decided to use the salient as a launch point for an
offensive into Flanders, designed to break through the front and capture the
German submarine bases on the Belgian coast. A successful action would not only
put the submarines out of action, but shorten the allied lines and potentially trap
a number of German troops behind the new lines.

Engineers from both sides had been tunnelling under the Messines ridge since
1915, until, by the spring of 1917, 21 huge mines had been laid under it totalling
450 tonnes of high explosive. At zero hour at 03:10 on June 7 1917, after 4 days
of artillery bombardment, 19 of the allied mines were detonated killing 10,000
German troops in half a minute. Of the two remaining caches, one exploded
during a thunderstorm in 1955, fortunately only killing one cow; the location of
the 21st cache is believed to have been found in recent years, but no attempt has
been made to remove it. The detonation of the mines was the loudest man-made
noise ever made to that date, audible as far away as Dublin. Nine allied infantry

divisions attacked and were supported by 72 tanks. They managed to achieve the initial objectives due to the huge mines and the fact that the German reserves were too far back to intervene.

On July 1917

As a second stage of the action, General Sir Hubert Gough was put in charge of the attacks to secure the Gheluvelt Plateau which overlooked Ypres. Huge numbers of guns were moved into the area and started a four-day bombardment, but as always, this simply served to warn the Germans of a coming offensive, allowing them to move in more troops.

On July 4 the Germans used mustard gas for the first time. It attacked sensitive parts of the body, caused sneezing, followed by eyelids swelling, then inflammation of the eyes, blindness for about 10 days and great pain.

One problem in carrying the offensive forward was the Yser canal, but this was taken on July 27 when the Allies found the German trenches empty. (Front lines were often vacated at night to reduce the casualties caused by night time shelling.)

On July 31 Haig's offensive opened with a major action at Pilkem Ridge, with allied gains of up to 2000 yards. The Allies suffered about 32,000 casualties, killed, wounded or missing in this one action.

Ground conditions during the whole Ypres-Passchendaele action were atrocious. Continuous shelling destroyed drainage canals in the area, and unseasonable heavy rain turned the whole area into a sea of mud and filled crater holes. In order to walk up to the front, duckboards were laid across the crater holes. Troops walking up to the front often carried up to 100 pounds (45 kg) of equipment: if they slipped off the path they could slide into a crater and drown before they could be rescued. Bodies buried after previous actions were often uncovered by the rain or later shelling.

September 1917 (first postcard is 16th sept 1917; Leo was involved in the fighting and had a moustache for the rest of his life to cover a shrapnel scar on his top lip.)

During September and October, after awful weather in August and many failures in attack due to poor planning and preparation, a policy of "bite and hold" was adopted by the allies, intending to make small gains which could be held against counterattack. Sir Hubert Plumer had now replaced Gough in command of the offensive.

1,295 guns were concentrated in the area of the attack, approximately 1 gun per 5 yards (5 m) of attack front. On September 20 at the battle of Menin Road, after a massive bombardment, the Allies attacked and managed to hold their objective of about 1,500 yards (1,400 m) gained, despite heavy counter attacks, losing 21,000 casualties. The Germans by this time had a semi-permanent front line, with very deep dugouts and concrete pillboxes, supported by artillery that could be accurately pointed at the attacking troops.

Further advances at Polygon Wood and Broodseinde on the south-western end of the salient accounted for another 2,000 yards (1,800m) and 30,000 casualties. The British line was now overlooked by the Passchendaele ridge and it became an important objective. An advance on October 9 at Poelcapelle was a dismal failure for the Allies, with minor advances by exhausted troops forced back by counter attacks.

First Battle of Passchendaele

The First Battle of Passchendaele, on October 12 1917 focussed on a further attempt to gain ground around Poelcapelle. Again, the weather was awful, artillery could not be brought closer to the front due to the mud, the Germans were well-prepared and the Allied troops were tired and morale was suffering. The result was 13,000 casualties with minimal gain.

By this point 100,000 men had been lost, for limited gains and no strategic advances.

Second Battle of Passchendaele

At this point two divisions of the Canadian Corps were moved into the line to replace the now-decimated Anzac forces. After their successes at Vimy Ridge and

the Battle of Hill 70, the Canadians were considered to be the allies' elite force and were often sent into the most horrific conditions.

Upon his arrival, the CiC General Currie stated he believed the objective could be taken, but only at the cost of 16,000 casualties. Haig, by this time inured to such high numbers after years of allied losses in the hundreds of thousands, ordered the offensive to continue; the Canadians moved into the line during mid-October.

On October 26 1917, the Second Battle of Passchendaele began with 20,000 men of the 3rd and 4th Canadian divisions advancing up the hills of the salient. A further 12,000 allied casualties occurred during the day for a gain of a few hundred yards (metres).

Reinforced with the addition of two British divisions, a second offensive on October 30 resulted in the capture of the town in blinding rain. For the next five days the force held the town in the face of repeated German shelling and counterattacks, and by the time a second group of reinforcements arrived on November 6, 4/5ths of two Canadian divisions had been lost, casualties Currie had predicted, almost to the man.

Their replacements were the Canadian 1st and 2nd divisions. German troops still ringed the area, so a limited attack on the 6th by the remaining troops of the 3rd division on a machine gun post allowed the 1st division to make major advances and gain strong points throughout the area. A follow-up by the 2nd division on November 10 completed the battle, by pushing the Germans off the slopes to the east of the town. The high ground was now firmly in allied control.

Aftermath

Haig, remembering the failure to follow through at previous battles, determined to continue the attack, believing that the Germans were ready to break. The attacks achieved at least part of their aims of mutual attrition, reducing the German strength and morale in preparation for attacks elsewhere.

In August and September, 140,000 allies had been killed or wounded, with a further 110,000 in October, and with similar numbers on the German side.

Haig's view was too optimistic though, and the Germans counter-attacked in a major offensive aimed at Paris on March 21, 1918. A subsequent German offensive in the north on April 9-April 29 (the Battle of the Lys, or the Fourth Battle of Ypres) regained almost all of the ground, an advance of up to six miles (10 km) taken by the allies in the Third Battle of Ypres/Passchendaele.

These battles, and those British and Commonwealth soldiers who gave their lives, are commemorated at the Menin Gate Memorial in Ypres, the Tyne Cot Memorial to the Missing, and at the Tyne Cot Cemetery, the largest Commonwealth War Graves Commission cemetery in the world with nearly 12,000 graves.

Passchendaele is frequently mentioned as an example of the horrific number of soldiers killed, maimed or lost in action that occurred in numerous battles of World War I, and the name itself has come to be used as a synonym for pointless slaughter. The Germans lost approximately 250,000 men, while the British Empire forces lost about 300,000, including 36,500 Australians; 90,000 British and Australian bodies were never identified, and 42,000 were never recovered. An aerial photograph of Passchendaele taken after the battle showed over half a million shell holes in one half square mile (1.3 km²) area.

". . . I died in Hell
(they called it Passchendaele) my wound was slight
and I was hobbling back; and then a shell
burst slick upon the duckboards; so I fell
into the bottomless mud, and lost the light"

Siegfried Sassoon

1917

Battle	Dates
German Retreat to the Hindenburg Line	**14 March-5 April 1917**
The Arras Offensive	9 April-16 June 1917
The Battle of 1917 Messines	7 June-11 July 1917
Operation Hush, 1917	Cancelled
The Battles of Ypres 1917 (Third Ypres, or Passchendaele)	31 July-10 November 1917
The Cambrai Operations and associated actions	20 Nov-30 Dec 1917

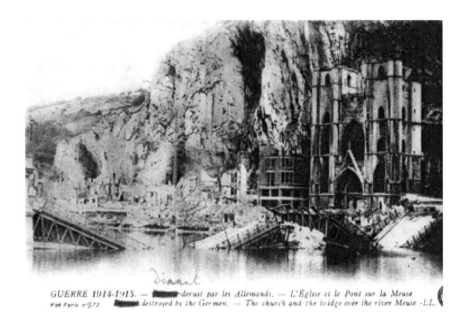

GUERRE 1914·1·15. — ████derwat par les Allemands. — L'Église et le Pont sur la Meuse
vue Paris n°572 ████ destroyed by the Germans. — The church and the bridge over the river Meuse -LL.

Sunday 16th September 1917

My dear Marie,

I am going to send home this type of card. We buy them in books of 20 and I
think they will serve as interesting souvenirs as well as letters. Re yours of 11th inst.
I am pleased to hear of your room arrangements. You will be spick and span at any
rate which is a nice thing. I thought too that you would enjoy the flowers I sent.
I shall go to see Cheeseman this aftn. Before going to evening service. He hints he
may be coming back but I think it very unlikely.
Three of my chums (Tom G yesterday) White (on Friday) & Wilton (today) are on
leave now, and as Jim Sedgewick is orderly Corpl. today I shall be on my own at
service tonight, probably.
Thanks very much for the photos. They are good—especially Chetham's. Have you
seen him lately? I had to risk over-exposure on behalf of bad light, and the rush to
get them taken. Cherrio, darling. Sorry to hear Aunt Rennie has been poorly again.

Yours, with love.Leo.

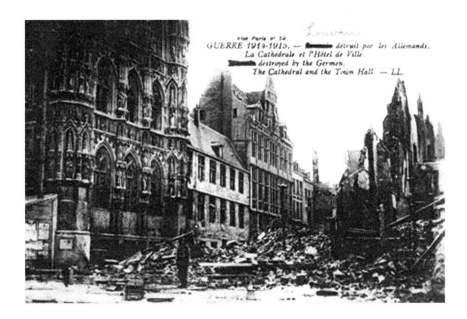

Vue Paris n° 54

GUERRE 1914-1915. — ▓▓▓ détruit par les Allemands.
La Cathédrale et l'Hôtel de Ville.
▓▓▓ destroyed by the Germans.
The Cathedral and the Town Hall. — LL.

Tuesday 18th September 1917

My dear Marie,

I am pleased things are going on smoothly—waiting for the time when we return.
You have had some busy days indoors lately but it would take your mind off the
war a little. So Billy Walker has joined up. Well I hope he will get along well and
come through allright, at one time he, Mansel Bevan and I were often together.
I am hoping to get a look at "Bullets" after a bath tonight.
Do you notice that on these p.p.c's reference is is made to Germen!
It is a compliment to you that you should be asked to bake the cakes for Hilda's
party. I hope you'll soon be regularly on that "fatigue" in our home. I shall get a
piece of lace for H. Next week.
Sorry I omitted Harold Sheperds letter. I enclose it this time. Can't tell you
anything more of Percy for the moment. Cheerio darling,

Your Loving chum,
Leo.

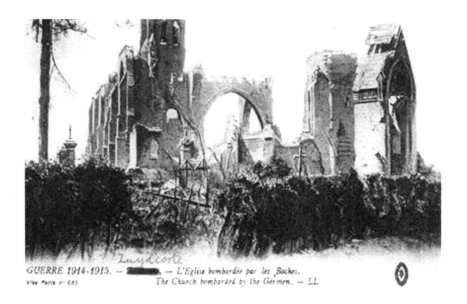

GUERRE 1914-1915. — ██████. — L'Eglise bombardée par les Boches.
Vue Paris n° 685 The Church bombarded by the Germans. — LL

Saturday 22nd September 1917

My dear Marie,

You have had a time with the people in High St., Brum. And you will have to
most certainly have to settle definitely on the actual thing paid for. Either that or
nothing. I know you won't be put off.
I'm sorry to hear of the troubles of Dad and Jim at 97, also it is a severe loss
to Doris Swains, Fred Wyton was an exceedingly nice fellow. I haven't seen
W.Baumont since but hope to in next few days. He is only a few min's away.
Pleased to hear Aunt Rennie is a little better now. Bye the bye you haven't sent me
that "odd volume". The boys here are a little hard up for reading matter & it will
go round well. Everything here as usual. Lots of rumours of course. Did you see
that Lord Derby had visited Lancs and Cheshire Gunners on the Italian front?
I have swapped 2 of the badges. Cheerio,

Your loving chum.

Leo.

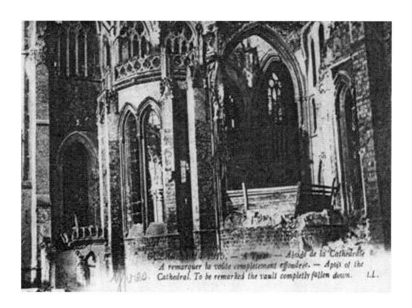

A remarquer la voûte complètement effondrée. — Apsis of the Cathedral. To be remarked the vault completly fallen down.

Monday 24th September 1917

I heard from Hilda today & as I had already bought some lace for her I'm posting it at once. She tells me that dad is very poorly. I hope he will pull round before long.

We are having a very hot sunny day today. Which 2 Hun 'planes tried to liven a bit without succeeding in anything but straining our eyes and necks as they flew at such a great height. The crashing & flashing of gunfire has been heavy the last few evenings. Papers not so regular down here of late—I expect they are snapped up on account of good news.

Cheerio darling,

Your loving chum,

Leo.

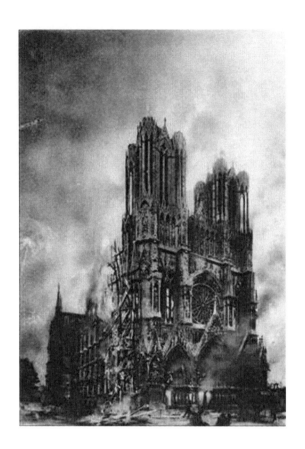

Wednesday 26th September 1917

My dear Marie,

I am so sorry to hear that Mrs Divinis' son has been killed. It will be a big blow to her. Please give her my sympathies. I hope Graham was able to get over to see you. Pleased to hear you have decided to go and see about your teeth. It is rather a mix-up, through army calls, with the dentist. Your room must be looking very nice now. I should like to see it. I have had a number of small "odds and ends" lately but haven't been too busy.

Cheerio darling,

Leo, Yours ever.

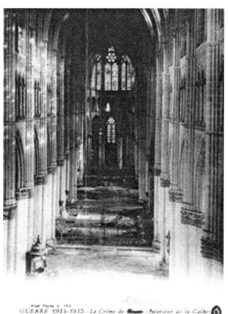

Sunday 30th September 1917

My dear little girl,

Did you write to Mrs W. about her offer? I see you refer to a letter of Dolly W's. Pleased to hear of your visits to hospital, and the return visits that the wounded boys are to pay at 361. are you still collecting their autographs? And I'm pleased to hear aunt Ada is going as the boys must find hospitals some distance from home very lonely and wearisome. So Dad and Jim are much better—that's good. Tom G. is still here, so he may not go for a few more days. We had a most brilliant moon all last night and there was evidently anti-aircraft work some distance off as we saw the flashes. It was an exceptionally cold night, and there was a tremendous bombt (bombardment) raging somewhere. I can hear the guns now.
The High St. people were evidently anxious to square things at the finish.
Pleased to hear all is now O.K. I am fit barring cold in the head which is better today. Your loving chum, Leo
(Annie visited wounded soldiers at a hospital based in Handsworth.)

Thursday 4th October 1917

My dear Marie,

Thanks so much for the regularity of your letters.

You appear to be having some busy times lately, especially in connection with hospital visits. The papers (including) "odd volume" came to hand yesterday. I posted the parcel y'day to dad (361). I am a little in doubt as to what to get for dad at (&. Do you think he would like a pair of slippers? If so what size? Do you happen to have a South Wales borderers Badge with white metal wording S.W.B. in centre? If not, <u>do not send</u> the all brass.

I had a nice letter yesterday from my civilian friends who have moved from Steen to Hazelbrouch. Will send it along later on.

Very rough windy day today and dull. Quite a change from the dry still days we have had lately. Autumn gales I suppose.

Mrs Cookes letter is to hand today & is a nice one. Pleased to hear everyone is fit at 97. I hope to hear of Hilda's lace being received by tomorrow's post.

Your loving chum,
Leo

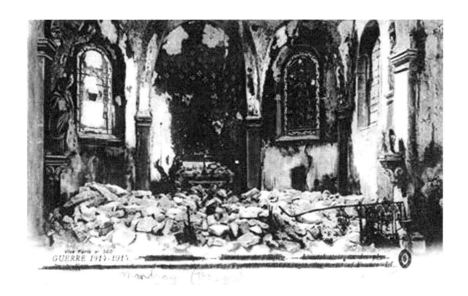

Sunday 7th October 1917

My dear Marie,

As this has been my 3rd spell on engine work again I can give you some idea of it. It interests me to get back on to it as it as it's such a change from office work. The job is allright and so far nothing has troubled me as regards picking up details again. So much for that.

Now your letters. I am glad to note from the latest that dad (at 97) is better. Poor Jim—this must be the 4th or 5th accident to his hand. Poor boy, he is going through a tough time. You are right about the present separation. "It's sickening" as we say. You mention reprisals. I felt just like you until recently but the absolutely tip top and efficient way our planes have been at work lately—see the regular bombings (tons each day) in the papers, suggests that it would be wise to leave the battle front planes undisturbed as regards numbers.

Pleased to hear Hilda received the lace. I thought it would be liked. I will try to send you some later on. I mentioned it to you whilst on leave. Cheerio darling.

Leo

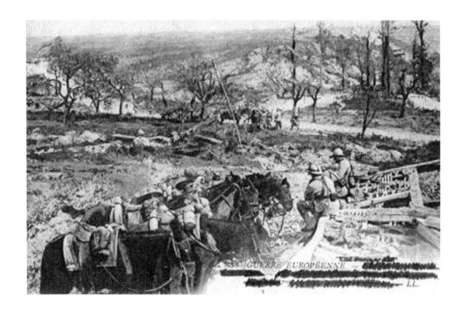

Tuesday 9th October 1917

My dear little girl,

Once more—thank you for the regularity of your letters.

You did really give me a surprise, in the news about Fred Sutcliffes. You will have a very nice time if he can manage to get over. I wrote to him some weeks ago but the Australian mail is 6 weeks en route. You must give me his address please and I shall hope to see him out here later on. You didn't enclose his address.

So Alan is coming for the weekend. No wonder it stirs memories of his last leave. Rather queer that Eric can't manage one, isn't it?

Nice today. Work going down allright and my cold is merely a slight cough now.

Cheerio and heaps of love

Your loving husband

Leo

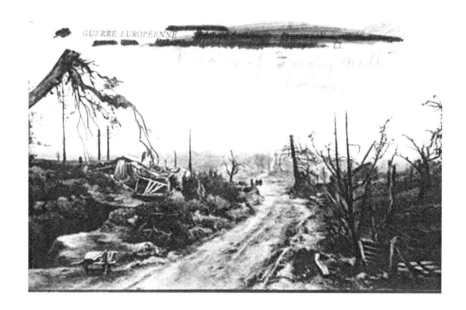

Sunday 14th October 1917

My dearest Marie,

It is a glorious afternoon. I had a nice walk this morning round the town and park not far away. My working shifts commences at 5 tonight so I'm afraid the service is off for me tonight.

Now to your letters. I am feeling much fitter as a result of the new work as there isn't so much leaning over a desk and we get odd fatigues in the open air. My cold has disappeared. As you say we will hope for October 1918.

I will certainly look at for your money to "greatest of these". I believe you help as much as by visiting hospitals, though I don't want to hint at checking your visits. Pleased to hear you have posted parcel to Mrs Quance. I sent Percy's belt home yesterday. There is no need to mention my suggestion re slippers. I enquired about a pair (for dad at 97) this morning and hope to get them next week after pay.

I certainly hope to hear of all your little troubles. I like to know just how you are faring. Cheerio, dear chummie,

Your loving husband

Leo

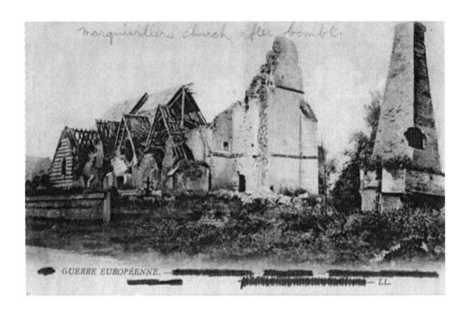
marquivilliers church after bomb[.]

GUERRE EUROPÉENNE. — LL.

Tuesday 16th October 1917

My darling lassie,

I had a fairly busy day yesterday on from say 6am to about 5pm. On this present job one seems to get a full day then a quiet day. I am beginning to feel as thoroughly fit and well as I was on my first job out here. What appetites I have had lately!!

I am surprised to hear that Hilda has passed for the WAAC. It may be for the best but candidly I hope they place her for service in England. You are having some nice times with the nurses and visits to hospitals and Rednal.

I am so sorry to hear about Capt. Powell. Do you remember him in our C.L.B. Next week I hope to get those shoes for dad at 97 and I shall get a pair the same size. Pleased to hear that dad is much better. I notice you are going to Kidder. But shall continue now to send to 361, as the period will be well forward by the time this gets home. I am looking at Bullets again. French is progressing well. Cheerio, darling.

Your loving chum.

Leo

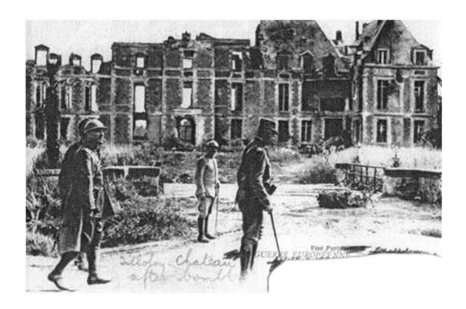

(Section cut out by censor to hide the location)

Thursday 18th October 1917

Dear Marie,

From your letter received today you have made the journey to Kidder. Hope you'll have a decent time.

I haven't much to write as I've had a certain amount of work which has filled up my time and a job cropped up just as I was going to start this.

The job is going on fine and I am nicely in touch with the engines now. I seemed to pick up the details without much trouble again.

Cheerio chummie,

Your loving husband,

Leo

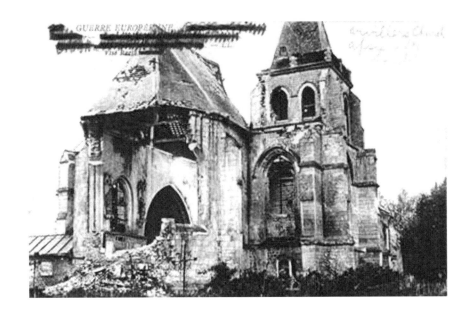

Saturday 20th October 1917

My dear sweetheart,

I didn't write a green env. yesterday as I hadn't anything particular to say. I shall probably send one next week.

Thank you for F. Sutcliffes address, also particulars re City address. So Graham is now located at an antiaircraft place. I would like his address please. Sorry to hear that grandma is not up to the mark. I wish I had been with you among the fruit!!! Especially with my present appetite.

Work is going smoothly. Did I tell you that we are working a gas engine! It runs well but is hard to start; so we get some muscle practice—physical jerks. The weather the past few days has been fine and dry—just a trifle cold but it keeps off the mud. Heard from Alan yesterday and Hilda today.

Cheerio,

Your loving chum

Leo

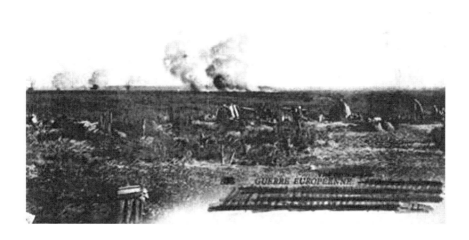

Thursday 25th October 1917

My dear lassie,

Owing to an extra long shift on engine today (due to irregularities in the other eng.) I find I've just 10 mins before post goes.

I believe I mentioned the 27th in my last letter—of course it was the 29th. I had in mind, and 27th as day of enlistment.

I had a very pleasant evening last week with Billy Beaumont and he is coming again tonight.

Cheerio darling and best of love.

Your Leo.

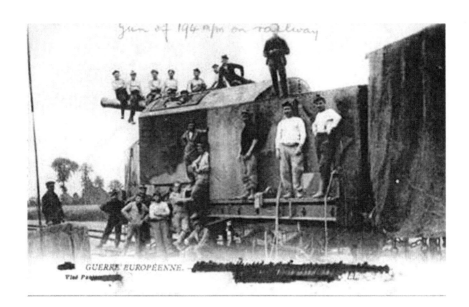

Saturday 27th October 1917

My dear Marie,

Once again—are you keeping your soldiers autograph album going. If so you are likely to have a fine souvenir of hospital visits.

You mention the lace subject in letter today. I will leave it till you refer to it again as you understand the position of things. I have made a note of what lengths you would like and shall supplement them if possible.

I have been in the army 2 years today, and Percy who went with me sits now at the same desk, writing home.

Cheerio, darling

Yours ever

Leo

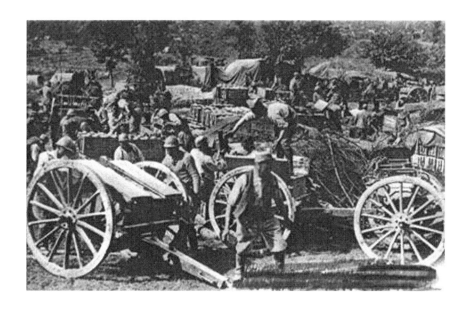

Monday 29th October 1917

My darling wife,

To remind you that I don't forget this day. Needless to say my thoughts are of you and of 2 years ago.

I got the slippers away to dad at 97 today.

Thanks for "John Bull" and I notice your little item in same, which I shall keep.

After a cold but dry day it has turned to rain tonight. As I'm not on work tonight, a nice fire and spare time for French and correspondence comes in handy.

The censoring officer would not pass Fred Sutcliffes letter for return to dad.

Pleased to know you've seen Chetham again.

Best of love and wishes, you're loving husband.

Leo

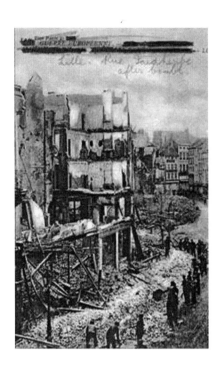

Wednesday 31st October 1917

My dear Marie,

The newness of the work has now gone, after nearly 5 weeks on it but I feel just as much interested and am always on the look out for new items or better running.
On the whole we are having cold but dry weather, though we've had sou-westerly winds and rain lately, at intervals.
Billy Beaumont frequently passes engine house whilst I'm on duty so we get an occasional short chat.
Glad to know you were keen on my letter of 23rd, I have written Eric, also Fred Sutcliffe.
So sorry to hear of your bad cold. Now a little hot milk and rum!!!!
French, correspondence, reading and cards, with "Bullet" attempts fill my spare time pretty well these evenings and other times off duty.
Cheerio, darling—don't take the Italian reverse too much to heart.
Your loving chum,

Leo

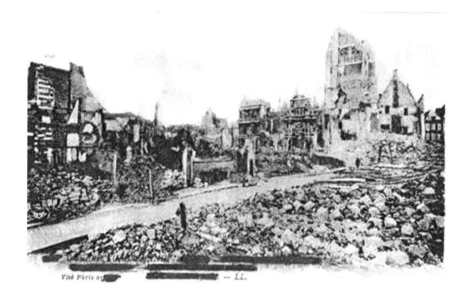

Sunday 4th November 1917–3.30pm

Dear little wife,

Percy left yesterday afternoon so by this time he should be nearing London. He has 14 days leave. This 14 day stunt has recently started.
Thank you for saying you have missed me "every hour of the past 2 years". Not every hour, dearest, for there have been 2 leaves, but I understand.
Tonight I am free so I am going to the service and hope to stay to partake of communion.
We are having very mild weather at present.
Yesterday I had a slight accident. An iron leg fell against my face cutting my cheek open a little. It was healing well last night and is Ok today. Doesn't smart. I only mention this because you would notice any small mark and Percy might refer to it.

Cheerio,

Your loving husband,

Leo

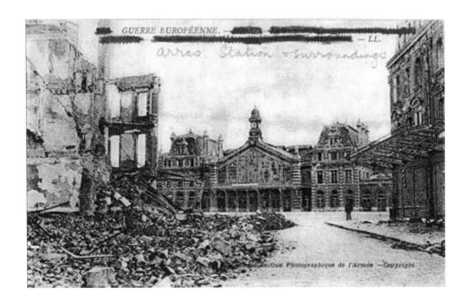

Tuesday 6th November 1917

My dear lassie,

I am sorry to hear you have had such a troublesome cold and hope by now it is
better. The cut on my face is healing finally. It happened on sat'dy afternoon and
by satd'y night the scab had formed on it, so my blood must be in good condition.
I've had it painted with iodine once or twice to be quite sure of it.

My dear when you "read the papers and they talk of a long war" you mean
the "Daily Mail". I certainly think it better to face facts than to indulge in the
"fatuous optimism" of some of the dailies and weeklies. I am a "whole—hogger"
on the "mail" spirit. One hardly likes to suggest <u>too</u> much but the "Daily Mail"
criticisms (by Admirals and Naval folk) of Naval matters is followed by an action
in the Caltegat, according to Sundays papers. And one <u>can't</u> forget aeroplanes,
munitions, and other items less gigantic. So I hold to it despite high official
utterances that the end probably won't come at least before July next. Don't
despair for the Italians but trust in the Western Front.

Thanks for the "Lectures" leaflet. I will do as you wish.

Cheerio darling Love Leo

Thursday 8th November 1917

My dear chummie,

I have got my 2nd French course & have made a good start on same.
The cut or break on my face is almost better. Half of the scab is clear & only a bit remains. I am surprised at the speed it has cleared away.
No doubt Percy has seen you by now. This is a card he gave me recently.
He said he would hop round on his bike to see you. I hope you were in this time.
Work is going down well and so far I'm glad to say there's been little of difficulty to interrupt.
I am going to have a go at some Titbits Competitions this week. Have had a look at 'bullets' & got one or two, but today I noticed Titbits and the subjects are of interest the closing date is Thursday next.
Cheerio darling. Mails irregular lately—haven't had a letter for 2 or 3 days.

Your loving chum, Leo

Saturday 10th November 1917

My dear chummie,

I intended writing a green envelope for post tonight but one or two causes were against it. I got "home" from work at 1pm and had such a big dinner that I was absolutely indolent all the afternoon. I hope you'll forgive me this lapse, as I know you look forward to them. Will try and manage it, next letter.

Had a letter yesterday from Dad at 97 acknowledging receipt of slippers which he evidently appreciates. I will reply to your very welcome letters in my green envelope.

French is becoming interesting, though stiffer as I am in the subjunctive mood lessons. Work and general health as usual.

Your loving chum

Leo.

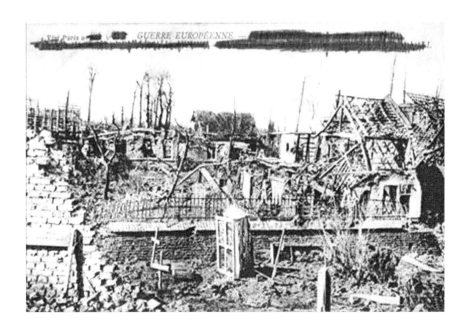

GUERRE EUROPÉENNE

Tuesday 13th November 1917

My dearest,

You will wonder why the green envelope is not arriving. Well the fact is I've felt so unwell since sat'dy night that this is the second bit of correspondence I've done since then. And I've put this off as long as possible today. I ought to have gone sick but one never knows whether one maybe admitted to hospital and then it's a rare rigmarole. I seem to have had my old time "November cold" do you remember. Headache and tired feeling in small of back and an absolute listlessness. So I've been on the bed at all times possible and feel better tonight.

Cheerio darling

Your loving chum

Leo.

Thursday 15th November 1917

My dear lassie,

I am feeling better as the shivering sensation has gone. I still feel a headache and I'm not quite OK.

The past few days have seemed to be almost unreal. I seemed to do things in a mechanical sort of way—my headache was so intense. It may be through being run down so as the headache goes and I feel fitter I'm going to try the "egg touch" again.

I received a rather doleful letter from you yesterday, I shouldn't attend such lectures if they are going to upset you.

Love from,

Leo

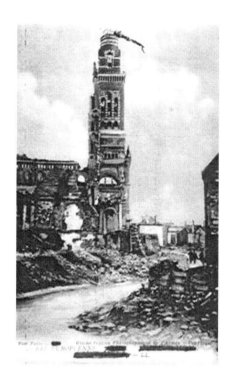

Monday 19th November 1917

My dear chummie,

I am undoubtedly much better and can say this morning that I am fairly fit again. Went in to a very pleasant service last night and stayed for communion a lot at both services.

Percy arrived early this morning and gave me the news. It seems he called on the Thursday morning so I expect your next letter will mention it.

Thanks goodness I feel fit again—it has been a rotten time I can tell you. Quids in now. Which reminds me I'm drawing less now having cleared things a bit and I hope before long to start sending you small sums.

Owing to more fellows coming up here. I am free until my evening shift today—the first time for some days as we have been short of men.

Cheerio and best of love,

your loving chum, Leo

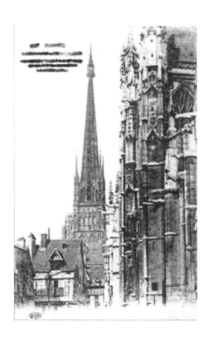

Wednesday 21ˢᵗ November 1917

My dear Lassie,

One or two of your letters need an answer. Pleased to hear Miss (Chuck) Wills
has been to see you again. Thanks in anticipation for the Punch Almanac. By the
bye will you please send two more packets of sticking plaster. It has come in handy
both for myself and other fellows many times.

Yours of 15ᵗʰ I have managed to borrow a watch to carry on with so there is no
desperate hurry for my other. Pleased that Percy called. He got back here the day your
letter arrived mentioning visit. No doubt you noticed in one of his letters I sent you
that he wished he could get back to me as we are such firm pals. I was indeed very
queer a week ago but I'm now feeling fit again and keeping up the hot milk touch at
nights. Had a good dose last night and it "bucks" one up well. If you can't get the watch
done locally take it to Spencers and explain the circumstances and ask them to do their
very utmost. Engine driving still going nicely, so there's nothing else to say at present.

Your loving husband

Leo

Sunday 25th November 1917

My dear Marie,

I had some letters from you yesterday after 2 or 3 days without any.
According to these, Hilda was building up her kit in readiness. I understood she
had gone, or was on the point of going. Send me her new address, won't you.
Yours of 19th suggesting that I had an attack of influenza. Perhaps I had but
I think it is more after the style of cold round the kidneys or the small of the
back—don't know the medical term for it—at any rate I'm well enough now. More
hot milk last night.
Pleased to hear the convalescent soldiers do not forget you when they go away. I
am sure you radiate comfort to them whilst they spend the often weary times in
hospital.
About the headaches I had, my bowels were fairly free at the time. I see you
"wrangling" your nursing and ambulance theories. As I go on the engine later
tonight I shall manage the service so all well.

Your loving chum

Leo

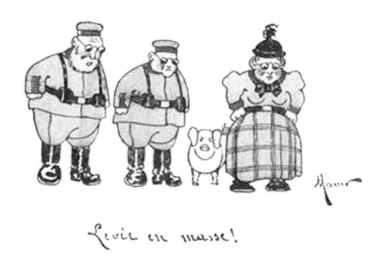

Levee en masse

Levee en masse—Call for all able men to defend their country.

Tuesday 27th November 1917

My dear chummie,

I have had a fairly busy time the past 2 or 3 days including a night shift, but I'm feeling fit and nicely in touch with the job.

I'm varying your card this time as it will be a change for your collection.

Answering your letters I will refer to your work question in my next green envelope.

By the bye a week after the little split in my cheek occurred it had healed and the scab was all off. A little blue mark remains and it is vanishing.

Glad to hear you've almost finished my gloves.

So you have bought a new hat. Pity the leave is as infrequent as the fashions. I suppose they will have changed before I get home again.

Hope you have my last green one by now—You should have today.

Cheerio, your loving chum

Leo.

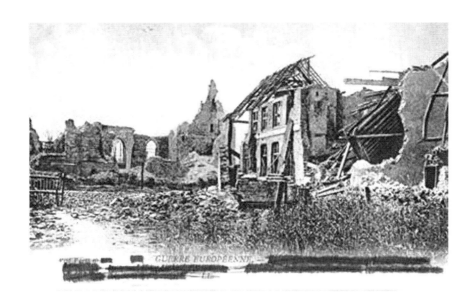

Thursday 29th November 1917

My dear Marie,

One or two little items of interest. After standing by in readiness to move for about a week, Billy Beaumont left here a week ago. Various rumours of course as to their destination—I fancy they have a good long trip in front of them. I got his home address and he took mine. It has been pleasant to see him at intervals when he wasn't out on detachment.

Percy has gone from here on detachment today. I don't mind it so much knowing that there is always the possibility of reunion whilst in the same coy.

I saw in Titbits the other day that to avoid colds one of the items should be not more than 40 cigs per week. As I had once more lapsed into the cig habit I'm going to do my best to cut it down to 40. A day and a half this week I smoked only 3 and felt no particular craving for them. Am fit and well and continuing the milk diet.

My best love, dear chum,

Leo

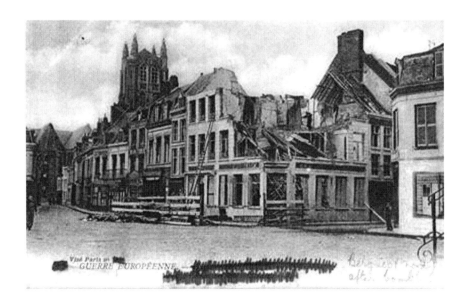

Sunday 2nd December 1917

My dear lassie,

I am just enjoying a little spell before tea. At work this morning & then a "wash
& scrape" after dinner ready for tonight's service. There is to be a band tonight &
the subject for the evening is home and home folks.
I am keeping fit & well now. Am continuing milk diet as much as possible its
wonderful how well one feels after a good drink of it—hot.
I haven't any news. It is cold but dry weather and one enjoys a sharp walk in it.

Cheerio darling,

Your loving chum,

Leo.

Goot gracious me ! Here kom
der W. A. A. C.

A card from Hilda (Annie's sister who had signed up for the WAAC)
Ilma was Leo's younger sister.

Dear Annie & Ilma,

I have had a card from Eric this morning saying he would like me to go down to Dover one day and as I was coming down from tea this afternoon who should I see in the park but Eric. I was glad to see a face I knew & I think he was too.

Lots of love Hilda xxxx

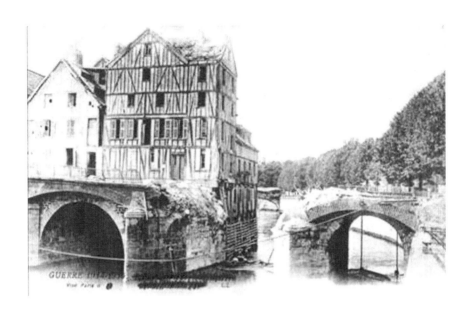

4th December 1917 (to Alan, his brother, also fighting in France)

My Dear Alan,

Re yours of 18th Nov. Do you really think I've never heard the expression "old china"? Have you ever heard of "old thing" or "old scout" or "old dear"? In case you haven't—about your "hen or a half" & co. I say 4 in 6 days.
Pleased to hear you keep on managing a leave. Keep it up—it's worth it for 361 folks and yourself. I do so hope that Eric will manage substitution this time. By the bye I saw in "John Bull" that the substitution officer in Brum had several Germans on his books but could not get them placed.
Talking of China!! Haven't we seen a lot of representatives of various countries at various times I've been in the same locality (up nearer the line) as Canadians, New Zealanders, South Africans, Australians English, Scotch, & Irish divisions (Welsh regts. included). As regards other nationalities "on the same job" I've seen Americans, French, Portuguese, Belgian, Chinese—and I forgot British Negroes.

Cheerio "old china"

Leo.

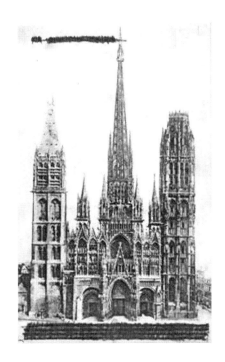

4ᵗʰ December 1917

Dearest chummie,

Thanks you for Hilda's address. I will drop a line or two to her at Folkestone. How do you like this card? It reminds me in part of Lichfield Cathedral & again of the Priory Church at Malvern. There is no doubt about the glorious work in French Cathedrals. I have noticed in one or two of them the prevalence of a circular window over the main door with a tracing of stonework cutting the front view of the window circle like this (drawing). I think Reims Cath. Is similar to this—this is not Reims by the bye. I am keeping fit & well, work as usual. What a nice long letter yours of 29ᵗʰ is—answering my green envelope. Glad to know you decided not to give up hospital visiting even if it eats up your money—you are doing something with time and money to help the State by continuing visits. Don't worry if you can't get certain items for the parcel.

Cheerio, darling lassie,

Leo

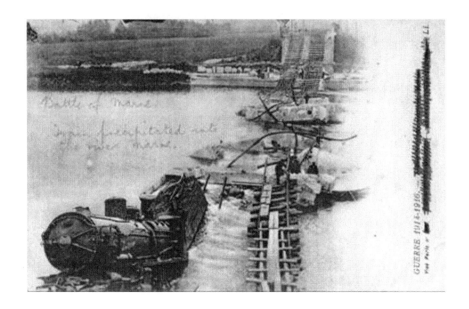

Thursday 6th December 1917

My dear Marie,

We are having a spell of cold, frosty weather but the air is grand and fresh. Once or twice snow has been near but so far only a few flakes have fallen.

Work is as usual and I'm well. There is little to mention at present when I've given these 2 items, I think it's a good job I started this p.p.c. study as often it would be a job to make a decent sized letter and I know the views are of more interest.

Can you please post my gloves at once? It is now cold enough for them now and Xmas parcels may be delayed.

Cheerio dearest

Your loving chum

Leo

Friday 7th December 1917 (written Thursday 6th)

My dear Chummie,

Yours of 2nd, together with dad's latest arrived today. So anxious now to have news from you. I hope the 'flu' is going allright but I shall be waiting now to hear further news, if only short letters.

I'm keeping pretty fit & well, though our rations are poor, that is the men's. I don't think it is the same all round. I'll be jolly glad when I am shut of being merely an impersonal item—a number. Things will be different when we do control our own affairs. By the way Percy had a letter yesterday saying that Tangyes were applying for our return (the 2 of us).

I hope to receive better news of your health in next day or two.

Goodnight my darling.

Love from Leo

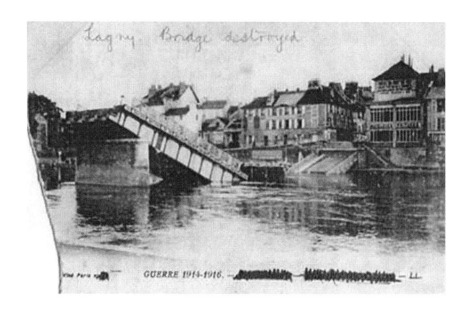

Monday 10th December 1917

My dear Chummie,

Thank you for the "John Bull" & letters to hand today.

I am waiting now for news from Billy Beaumont. He promised to write fairly soon.
We ourselves are in a state of chaos and I don't expect to be on my present job
much longer.

You were asking what I paid for milk. 4d a litre (say 1&3/4 pints so for 2d I get
nearly a pint. Quite enough for a drink & cheap compared with your figures.

In your letter today you refer to Eric meeting Hilda. I mentioned this to him in
writing recently. What a wash out St Chads is really, fancy not mentioning Hilda.
Of course she is a recruit for Khaki—just as we were in our twins.

Your loving chum

Leo

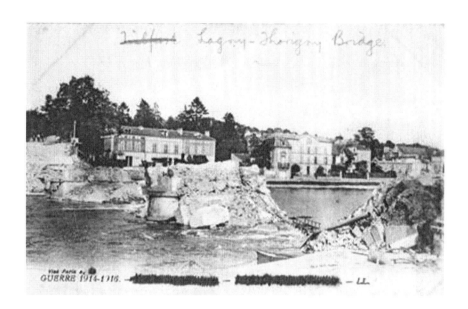

Wednesday 12th December 1917

My dearest lassie,

I am sorry to hear that Hilda is so depressed at present. Of course there is cause for it. With inoculation & vaccination making her so bad she must feel the lack of home comforts & attention. At such times it is natural that she would be low spirited. When she has landed in France the novelty of the situation & new scenes should help to make her normal again. I cannot say that I'm surprised as a girl is not like a fellow and in addition she is either lively or depressed & consequently irritable. If we have any faith we know she'll pull through and it will broaden her mind.

I told you some weeks ago that I thought Russia was not done with and the latest news suggests that Germany's peace hopes are likely to be disappointed on the Eastern front. For a long time I've noticed that the Cossacks seem to have been the best Russian friends of the allies. The sky begins to brighten again. What a wealth of honour & tradition falls to us in the capture of Jerusalem.

Your loving chum

Leo

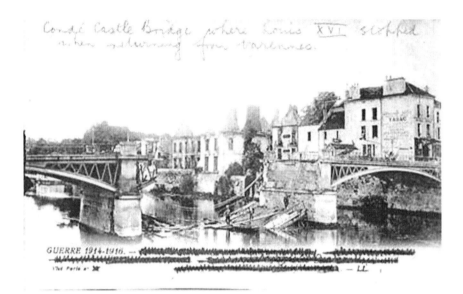

Condé Castle Bridge where Louis XVI stopped when returning from Varennes.

GUERRE 1914-1916. —

Monday 17ᵗʰ December 1917

My dear Chummie,

I shall not be going up to our new camp for a week or two as far as I can gather. 3 of us are to be left on the pumping here. So I shall miss any Xmas festivity at Coy.H.Qrs, but we who are left (including 2 A.S.C. men probably will have as pleasant a time as possible.

The gloves arrived one day after the parcel, they are fine—thank you dear, I wore them last night going & coming from the service. It was a cold night with light snow shower but my hands were warmer when I got in than those of the fellows sitting round the fire.

Pleased to here you are continuing visits to the hospital at present. By the bye I heard from Hilda on Satdy.

Cheerio & the very best of love,

Your loving husband

Leo

Thursday 27ᵗʰ December 1917

Dearest Marie,

Another of your letters to hand today, dated 16/12/1917 so I have already had
letters written afterwards.

You speak of Miss Wills calling. Which reminds me that I was to get a brooch for
her. Let me know when you want me to get it. "Somme" I think it was to be.

I am having another good dose of milk ce soir & hope to settle the cough. It has
been better today.

I am hoping that we shall not spend another Xmas in France and if the
leave period come up to expectation (& rumours!!) I may be with you about
Whitsuntide.

Your loving husband

Leo

Sunday 30th December 1917

My Dear Chummie,

The Three of us left our engine driving job and arrived here at our new camp late last night. I have more or less settled down now. Got a very decent bed and plenty of blankets. There is a small town about ¼ hours walk away, but once more it is somewhat of a contrast to find "home" represented by a camp with huts, instead of a brick or stone building. I was rather lucky about my bed. I slept last night on another mans place and arranged to make a double bed this afternoon. Then three fellows were moved this morning so I get a place in a corner. So "quid's in". Hilda is evidently a good distance from here now especially as we are nearer the lines.

Cheerio dear. Will write later.

Your loving chum, Leo

1918

Battle	Dates
The First Battles of the Somme	21 March—4 July
The Battles of the Lys	9 April-29 April
The Battle of the Aisne	27 May-6 June
The Battles of the Marne	20 July-2 Aug
The Battle of Amiens	8 Aug-17 Aug
The Second Battles of the Somme	21 Aug-3 Sept
The Advance in Flanders	18 Aug-6 Sept
The Second Battles of Arras	26 Aug-3 Sept
The Battles of the Hindenburg Line	12 Sept-12 Oct
The Final Advance in Flanders	28 Sept-11 Nov
The Final Advance in Artois	2 Oct-11 Nov
The Final Advance in Picardy	7 Oct-11 Nov

Wedy. 2nd January 1918

My Dear lassie,

I hope tomorrow or the next day
to send the lace I got for you
a few days ago.

The weather has changed today
to rain. Not much of it but it is a
change after biting winds or snow
for 2 weeks or so.

I have today recd. Another nice
letter from Mr Parkins, and a
little book of a similar nature to
the one he sent last Christmas.

I wrote Billy Beaumont last night.
What an interesting time he had.
Since I came up here I've been on
various jobs. Helping last 2 days
in the stores.

Will write green env. soon.

Cheerio. Best love from Leo.

Rum issue every night now!

GUERRE 1914-1916. —
Compiègne Bridge destroyed.

Thursday 3rd January 1918

Best Wishes and love from Leo.

Embroidered card From Annie's sister Hilda based in Wimereaux to Annie for her birthday

GUERRE 1914-1916. — ▬▬▬ — ▬▬▬▬▬ — ▬▬▬▬▬▬▬ — LL.

Sunday 6th Jan 1918

My dear chummie,

Pleased to note from letter today that you had recd. Green env. How did you like the Xmas day programme?

My cold is much better & I think during this weekend I shall be able to obtain fresh milk—I've discovered a place today.

After our rifle inspection & pay today I had a look around the nearest village, will try and send some photo's later. The weather still continues dry and frosty.

Tangyes seem to have adopted a curious rule. A man by fighting indirectly for them penalises himself if he happens to get a wound. On the face of it it is callous.

Aunt Marion will be in trouble over Ernest. Edgar's wife too will be a trouble.

Cheerio Darling—keep smiling.

Love from

Leo.

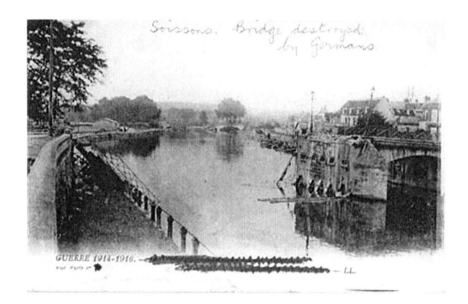

Soissons. Bridge destroyed by Germans.

GUERRE 1914-1916. — LL.

Tuesday 8th Jan 1918

My dear Chummie,

Once more I have had a move and I'm now some distance behind the lines again. I shall be on my own on a small pumping set soon. Means a hike.

Please note new address

(of 351 E&M.co.R.E.);
Attd.2nd Canadian Reserve Patrol Hedqrs;
BEF; France:

So you'll see I'm billeted with Canadians this time. Both the billet & the job promise to be very decent. The engine house is only a few yards from billet.

Cheerio and best love,

Leo.

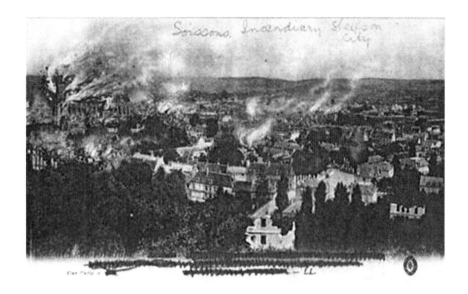

Friday 11ᵗʰ Jan 1918

Dear Marie,

I should have written yesterday but I didn't feel up to the mark and as the arrangements are not quite ready for pumping I spent most of the day in bed, having nothing else to do. Have been to the engine house this morning & straightened up a little so you'll see I'm feeling more like it.

On Tuesday after I had written you I went down to the nearest town (a few kilos away) to get one or two items for the engine house and found some old civilian friends of mine from Armetieres. I was only able to stay 2 or 3 hours but it was a pleasant surprise.

Cheerio—your loving husband,

Leo.

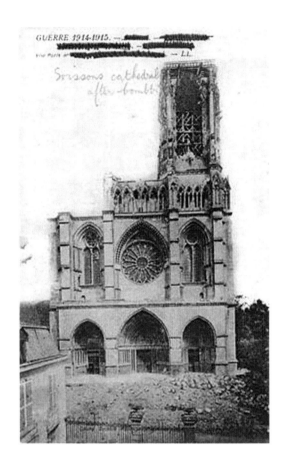

GUERRE 1914-1915. —

Soissons cathedral after bomb[...]

Sunday 13th Jan 1918

One more week nearer the end of it. I'm feeling almost fit again. Can't yet commence regular pumping so I only give engine & pump occasional short runs at present to keep 'em up to the mark. Expect to be running properly soon.
The weather is very variable. Early in the week we had frost and snow, then rain and a 2 days thaw & now frost last night. Today is fine & bright & I'm hoping to get a good walk in this afternoon.
Have seen quite a lot of Lancashire lads lately. They told of some of their recent experiences—poor old infantry.

Cheerio & best of love,
Your loving chum, Leo.

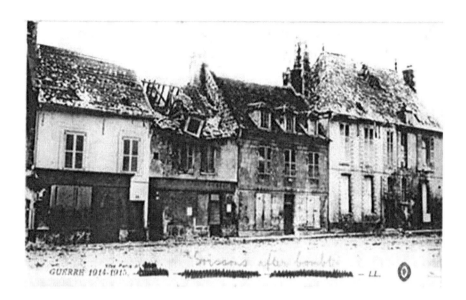

GUERRE 1914-1915. Soissons after bombt. — LL.

Tuesday 15th Jan 1918

Dear Lassie,

Last Tuesday I wrote giving my new address & today I have your first letter with new address. To answer your question I am again in France as a result of this move and we are so far back here that the guns only sound as a rumbling. So you'll know that shells etc. are strangers—I'm not at home to them.

Of course as a week has gone since I arrived I am more or less settled here now. Have a good palliasse which I have stuffed with husks etc of corn after threshing and it makes a grand warm bed, and the rations are good—much better than up at camp nearer the lines—or it may be that the cook arranges it better as the cook to my own coy. is not exceptionally good. Am busy painting & generally getting things ready for regular running now.

Cheerio,

Love from Leo.

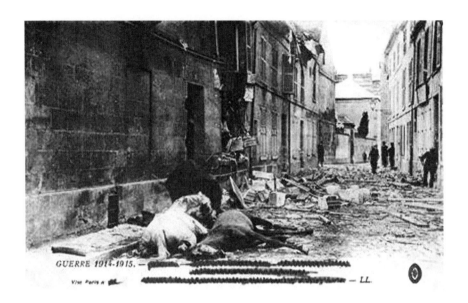

GUERRE 1914-1915. —

Vue Paris à — LL.

Friday, 18th Jan 1918

My dear Marie,

Yours of 12th reached me today. Re your superstition—I saw the new moon last night for the first time but not through glass as that is a commodity seldom seen in billets etc. out here.

I remember Jimmy Bates very well—who doesn't at Sandylands School & St. Johns. He was always flying about.

The watch will be of service. I shall be glad of it again as there is no minute hand on this one and I shall want to time the pump and engine more accurately.

The weather is simply atrocious the mud—!!! Today we've had hail, rain & snow. What more do you want? I expect it will freeze tomorrow or the sun will show itself. It's a long time since I noticed so many changes.

I had a very nice letter from Jim recently and one from Eric.

Cheerio,

Your loving chum,

Leo.

Friday 1ˢᵗ March 1918

Dear little girl,

I received more mail today from Coy. Hdqrs. You will of course know by now
of my move. By the bye leave has stopped for a day or two in the Coy. but this is
in accordance with previous ends of months. The beginning of another month
generally means larger allocation of leave to the Coy. So here's to March.
I saw a Somme brooch last night but didn't like its cheapness. It has been put by
for a day or two but I would prefer to buy the Peronne brooch which is pretty. The
Somme one is a little tawdry.
I am having very little pumping here. In consequence I'm doing some more
French & reading also. Thank you for the "visitors" and also for "John Bull". It
gives one something to do.

Your loving chum,

Leo.

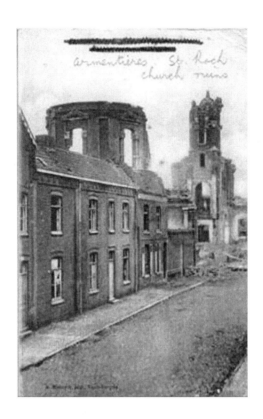

Wednesday 6th March 1918

Dear little girl,

Today there is little doing—yesterday I was fairly busy as brewing was taking place. I am continuing fit & well. Good meals, not much work, plenty of sleep are evidently beginning to tell on me for I shall have to alter my belt—as it is I have to take it off after dinner now—but don't mention this in case the Food Controller is about. Every now & then today the windows rattle with the force of gunfire or shells bursting (a long way off I should fancy). This peaceful place never seems to be troubled!!!
I have just been over the way & got your parcel. Thanks very much—by the way I'll write aunt Ada.

Your loving husband, Leo.

Friday 8th March 1918

Dear chummie,

Yours of 4th reached me today, addressed here. What fine long letters you are sending now. So Alan has been home again. I wonder if he'll be able to wangle leave if I manage it in the next fortnight or so.

I am glad to know you still hold fast to your churchgoing, even if you have changed your church. By the bye if you have taken 2 sittings it will mean that I may not get a seat with you unless I'm lucky. But we won't trouble about that just at present, eh? Enough time-!!

Pleased to hear Graham's little operation was successful. So he doesn't want to come to France again. Well if he flies in Italy he'll have plenty of excitement among the mountains I should say.

Love,

Leo.

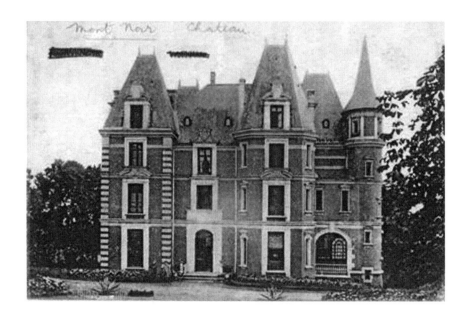

8th March 1918/2

I shall be interested in your account of the Social Dance. Should you have danced (I hope you did but I almost dare say you haven't) I should say "lucky man" to your partner or perhaps (to compromise with your conscience on poor hubby's account) you took gents part in dancing with other girls.

The Peronne brooch is one that will be liked I'm sure. There are brooches of Armentieres in the same style. If you haven't an Armentieres brooch-!!

I also had a nice letter today from Hilda—but she doesn't refer to smoking!! Austin mentioned this in a letter. Perhaps you forgot to mention this. In any case she can buy fags much cheaper out here than in Blighty.

Cheerio my love,

Leo.

8th March 1918/3

So I'm blowed if I'd send them to her. Apart from girls smoking I think that if I (a smoker) ask you not to send them on account of our canteens out here having good & cheap supplies, she can buy'em like I do. The first 2 cards I send now represent chateaux but I must say the first card doesn't seem much like a mansion does it? That's what I always used to imagine a chateau was like. On fine days there is a glorious scene here of a chateau nestling almost on top of a wooded hill half an hours walk away.

Cheerio, dear sweetheart,

Your loving husband,

Leo.

Sunday 10th March 1918

Dear Marie,

I haven't much to tell you this time. Glorious weather, a few heavy cannonades of late, little work; and you have the main news. I am feeling champion—as I ought to be in such comfy circumstances. Did I tell you of the Peronne brooch? I went to get it (in enamel) and they had sold out (had plenty of Messines, Ypres, Armentieres, lens & Doullens (Somme) in enamel) so I got a Peronne brooch in another style. Miss Wills I am sure will like it but I should have preferred it in enamel—they are so pretty.

Cheerio dear chum,

Your loving husband,

Leo.

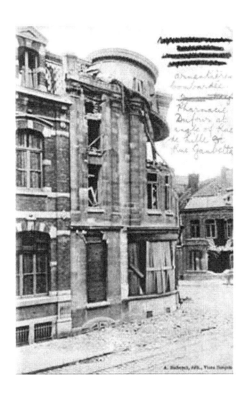

Friday 15th March 1918

My dear Marie,

Thanks for the regularity of letters, papers etc. I hope to write long green env.
letter on Sunday. Sorry to say I haven't news as yet of leave reopening but it may
be some consolation to you to know that my present circumstances are as happy
in all ways as it's possible to have them out here.
The engine is running very smoothly at present in the short runs I have to give it.
By the way Dolly Walton has sent me a S.D.A. paper each of the last two weeks.
Some interesting reading in parts of them.

Cheerio, darling,

Your loving husband,
Leo.

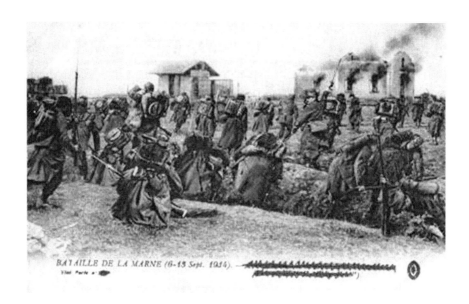

BATAILLE DE LA MARNE (6-13 Sept. 1914).

Tuesday 19th March 1918

My dear Chummie,

Have just finished my one busy day of the week—brewing day. As I start the engine up for the first time at 5-50am & for the last time at 6pm, you'll see it covers a fair number of hours. Don't run all day—short periods.

I had a splendid walk last night, to the top of the hill near us. At the top I had a real treat. For miles & miles the country lay in view, with a little church & cluster of houses here & there. I also saw shells bursting a long way off. It was a beautiful evening.

Today we've had rain all the time. First for many days. The old lady here is still feeding me up for Xmas. Referring to you as madame she says to me "what madam say, you plenty fat come?" She's a jolly old sport—makes me very comfy. In fact I'm Semi-civilian again!

Your loving husband,

Leo.

Thursday 21st March 1918

My dear little girl,

The days & weeks spin on and we both wait for "la permission", eh?
I had a call this morning from 2 sergts. of the Coy. Able to report everything
allright.

They told me leave had not yet reopened for the Coy. I was a little too sanguine
before but of course I always made the proviso, "if it continues". However,
looking back a few weeks I didn't anticipate it then before April at the earliest, but
prospects improved & I almost fancied March, when at Coy. Hdqrs.

After a wet day on Tuesday the weather is once more glorious. Fairly lively shelling
of different places lately—but none here!!! I am sticking French again. Not much
going in the pumping line, but on one bit there is the engine is doing very well.
Am feeling splendid and have enough to eat. Have read quite a lot of novels lately.

Cheerio dear. Keep hoping,

Your loving chum,
Leo.

Sunday 24th March 1918

My dear Chummie,

Just imagine what it would be like if the font of any church you know was
demolished by shellfire. So keep your imagination see other side of card.
We are without news—papers lately so have to be content with rumours of a
German attack. And you know the 50% reduction you have to allow on rumours!!
Glorious weather continues & the hedges are showing signs of growth.
I'm keeping A.1. in health (and temper). Leave has not yet recommenced, worse
luck, but we'll hope, eh?

Cheerio darling,

Your loving husband Leo.

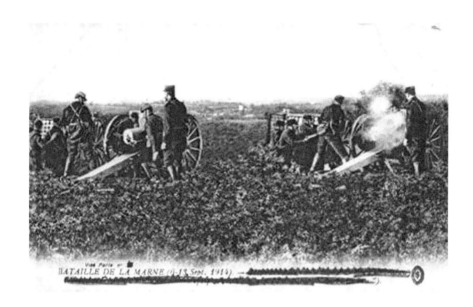

BATAILLE DE LA MARNE (6-13 Sept. 1914)

Tuesday 26th March 1918

My dear little girl,

The rumours of a Coy. move have seemed to have died down, so as far as I can tell I'm settled here for the time being. I've been here 4 ½ weeks now & don't want to move unless it is for leave as its nice in every way possible.

Not so many refugees flocking in now. In fact the last couple of days have been fairly quiet compared with previous 2 or 3. Dry weather but cold winds.

My busy day today once more, but I've had troops today for water & am likely to be a little busier in the future. All the better, too much spare time is liable to hang heavy—so I help the "old gel" with the pumping & odd fatigues she finds me, chopping sticks etc. And I've already mended 2 doors, a sewing machine, pump etc so I really wonder what I'm here for!!

Cheerio,

Best love,

Leo.

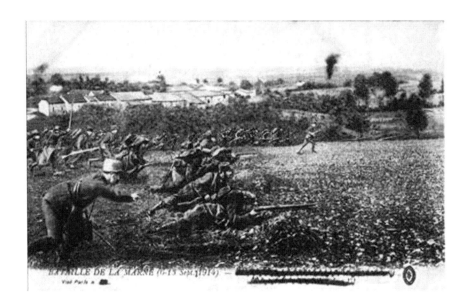

Thursday 28th March 1918

My dear wife,

Thank you for the regularity of the "visitors" & John Bull. I also had another
paper from D.Walton this week. Does she wish to "convert" me? I wrote yesterday
to the "Pelman Institute" as I'm a wee bit interested in their adverts.
We are quite unable to get a paper at present. I haven't seen one for at least 8 or
10 days & yet various rumours are coming through.
I am pumping a little more at present but still have spare time.
Very dull cold weather continues. At this time of the year one can see very plainly
the difference in English and French farming. Here it is often ploughed land
as far as one can see—in Blighty I couldn't help but notice on my last leave how
much pasture land there is.
Aren't you "fed up" with the war? Cos I am, with France.

Love from,

Leo.

Saturday 30th March 1918

My dear Chummie,

I wonder if your thoughts were like mine yesterday (29th & Friday) at 2pm?
Somehow I fancy they were as I believe in mental telepathy—Your letter nearest the
29th will be on the way before you get this.

I have been busy most of the day fixing up part of the engine & cleaning things
on same. We are having "encore" rain so I don't get out much at present o'nights.
I have been able to get a paper for Thursday, what a ferocious battle the present
one is. One can't help but think very deeply of our boys. And it's a stiff task for
leaders. What an Eastertide!! We used to look forward to it very much several
years ago.

Hilda wrote me a few days ago & spoke of a "rise" but I didn't know it was on
account of mounting a stripe.

Cheerio dear,

Best love,

Leo.

Wednesday 3rd April 1918

Dearest chummie,

Sorry I didn't write y'day. It was my busy day—I left it rather too late.

I am busier of late (this week I mean) than any previous week since I've been here and much prefer it so, from what Percy tells me he hasn't been very busy since I last saw him. I'm lucky to be out on det. as I hate standing by at Coy. Hqrs.

April weather here.

Quite by accident a lorry driver (since gone away) happened to notice the address on my letter to dad & mother on Monday last. He asked me what I knew of Brum and of course I said it was a letter for home. And his home is in a little road off Gillott Road!!

Hope to write a "green'un" on Friday.

Cheerio,

Best love, dear,

Leo.

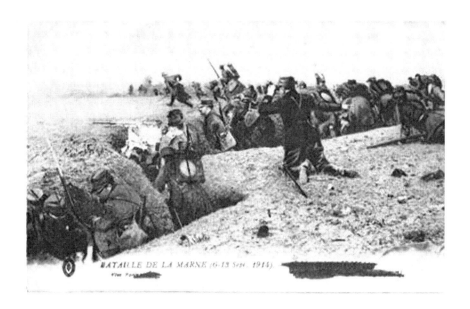

BATAILLE DE LA MARNE (6-13 Sept. 1914)

Sunday 7th April 1918

Dear little girl,

Pleased to hear you had such a nice time at "chuck" Will's place. I had a letter from dad (97) y'day—a long one too & interesting. He was free for a bit, he said. Your 5 hens have done splendidly during March. How do you get the corn etc. now? Is that rationed—so much per hen!!!
6 weeks yesterday since I came here. Everything is O.K & I'm feeling fit & well. Haven't heard any news as yet of leave but I hardly expect it at present. We will hope for April at any rate but it isn't right to be impatient in view of the big battle where our boys are facing terrible onslaughts while I'm comfortable here.

Very best love.

Your loving husband.

Leo.

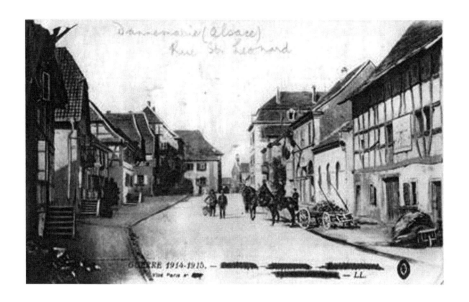

Tuesday 9th April 1918

My dear Marie,

Nothing of great event to tell you. I've been busier each day lately and hope the business will continue as too much time is apt to drag.

I had a nice walk on Sunday night & noticed many violets in flower. I enclose a few—they are the first I've seen this year. I also send one or two violet roots but as I've had them since Sunday they may not grow. Will try & send more & fresher later on.

Quite a surprise on Sunday when I had a letter from aunt Rennie, written in French. I know she's had a good education but I'm wondering if someone helped her in this case!!

Best love from

Leo.

Saturday 13th April 1918

My dear chum,

Just a few lines to say I've had to leave my job.
Am with the Coy. and although I'm tired am feeling O.K otherwise.
Further news as soon as possible.

Leo.

Thursday 18ᵗʰ April 1918

My dear little girl,

After 3or 4 days "on active service" (very) there is a chance to write a little more than a field postcard.

I am fit & well but if there was any superfluous fat on me, from my last pumping job it has vanished in the rush of past few days.

However the main thing is that I've nothing the matter and bar depressing weather things are going well enough and we are seeing life.

Your loving husband,

Leo.

Panorama of Poperinghe.

Tuesday 23rd April 1918

My dear, dear wife,

Started a green envelope last night but as I haven't time to finish it I think it best to catch a few mins. this a.m. as letters are being collected. We are now not far from the sea, am feeling O.K. The rations have been splendid considering difficulties that travelling brings. We had a good many hours in the train to do a few miles comparatively.

Cheerio.

Best love,

Leo.

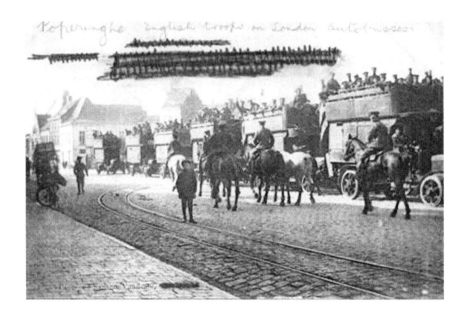

Friday 26th April 1918

My dear Marie,

I was very pleased yesterday to receive yours of 21st, the first for some days. You see the mails are following round so much lately.

We are O.K. down here, so far. I fancy I'm not so many miles from Eric but it is impossible to be sure.

There is a Y.M.C.A. close by, I have had a few pleasant turns on the piano there. It is our main attraction at present as the country around is rather flat & uninteresting.

Not too much work as we're expecting another move (not far). A trifle monotonous. I hope jobs on detachment are a thing of the not-too-distant future. Meanwhile we are getting plenty of fresh air + not bad rations.

Cheerio darling,

Your loving chum,

Leo.

27ᵗʰ April 1918

A.Lebleu. Refugee d'Hazebebisuck a la poste de Boulogne s/mer (P de C)

On active service 133325. Sapper Leo Sidebottom, 351 (E et M) Compangnee RE, Armee Britannique en France.

Cher Ami,

Depius le 13 nous sommes refugies ici, loges et nourris dans une ecole en attendant de retourner a Hazebrouck si la situation s'ameliore. Je voudrais avoir de vos nouvelles. Jenny, mon oncle et Grand-mere sont a Etamvoorde 23 rue de Popeigne. Grand—pere est mort dans ce village.

Alice.

Translation.
(Dear friend, Since the 13ᵗʰ we are refugees here, lodgings and food in a school waiting to return to Hazebrook if the situation gets better. I would like to have some news from you. Jenny, my uncle and my Grandmother are in Ebblinghem 23 rue de Popeign. Grandfather died in that village. Alice.)

85

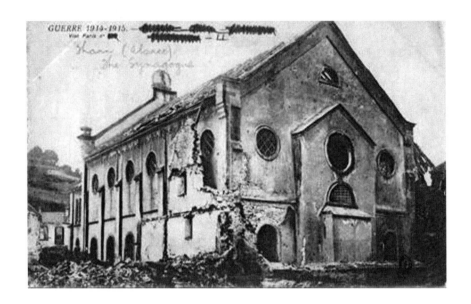

Sunday 28th April 1918

Dear little chum,

April almost out and it has been the most notable of all I've had out here,
barring perhaps my first month in P.Wood. What the future holds is a matter of
conjecture (which is another way of saying that it's a splendid field for rumour,
judging by the past). However, for the moment we are comfy here. Spare time for
our own little odd jobs. We moved a few hundred yards on Friday + are sleeping at
present in tents. I hope to get a glimpse of the sea tonight as it isn't far away.
I heard from Lebleu's yesterday. They had to move from Hazebrouck they say. You
remember them as old curlian friends of mine. They have gone to Boulogne for a
time.
I am fit + well. Managed to get to 6.30 Communion this morning—my first chance
since early in January.

Cheerio darling,

Your loving husband,

Leo.

Calais. Boulevard

Tuesday 30th April 1918

Dear little wife,

I had a trip into the town on Sunday evening. It's fairly interesting as there are one or two fine buildings + then there's the shipping part of the town which I had a decent look around.

We are "quids in" here with one exception; there are abominably cold winds, which keep one very cold in the daytime. We sleep warm enough. (I told you I think, that we are in tents). Otherwise things are decent. Good grub, plenty of leisure time and a very convenient Y.M.C.A, cinema etc.

Leave seems to be a forgotten thing. I don't think it will open just yet as really time on railways must be urgently needed at present.

Did I tell you that my last letter from Pontefract was written in French? Quite a surprise. Incidentally, I had to leave my French book, let alone new riding breeches, tan shoes etc when I quitted pumping.

Cheerio darling,

Leo.

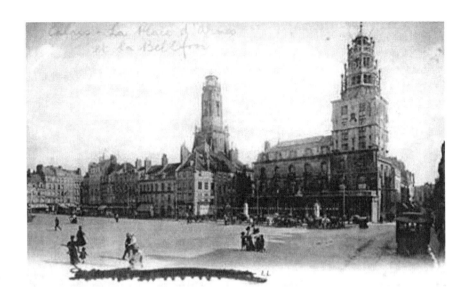

Thursday 2ⁿᵈ May 1918

Dear lassie,

Just a few lines to say I'm O.K. still.
The weather is improving & we are getting out of doors most of the day so there's not much harm coming to any of us.
Quite a lot of "whacks" about here and I believe there's a dance on Saturday night. Not much news. Letters from Blighty are very scarce at the moment.

Love from

Leo.

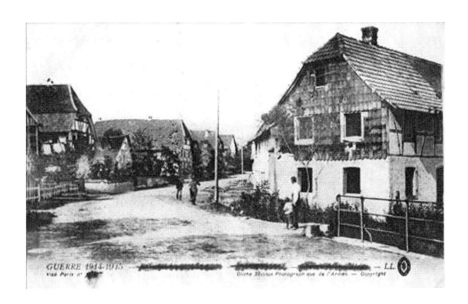

Tuesday 7th May 1918

My dear chummie,

Late on Sunday I received a batch of your letters dated 9th, 14th, 16th, 18th, 24th and 25th!! So now I'm quids in, especially as we had a green env. issue y'day.

I made up the parcel (2 spoons + brooch) yesterday but it had to wait till today as we hadn't sealed the knots for registration.

We had a fine day yesterday and consequently hopes of a dry spell arose within our "buzzums". Also this morning it is as wet as it could be.

Some of our fellows are leaving here today and tomorrow so if you decide to send the French Book do it quickly please as the rest of us don't know the length of our stay.

Hope you'll get the parcel alright.

Love from,

Leo.

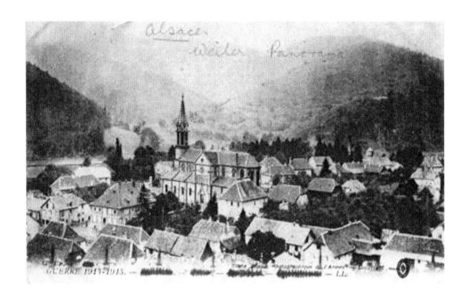

Wednesday 8th May 1918

My dearest wife,

We are still located in the same place, though for how long I can't say, some of the boys having left today. However we are quite content to stay for the time being. Tom G. left in today's party. Not having my French book, I'm having a round of concerts, cinemas etc.

The weather continues to be mixed. Fine today.

It cost exactly 2d to send the little parcel!! And that was on account of registration. I see by the bye that 1d postage is to be the continued rule for letter to soldiers.

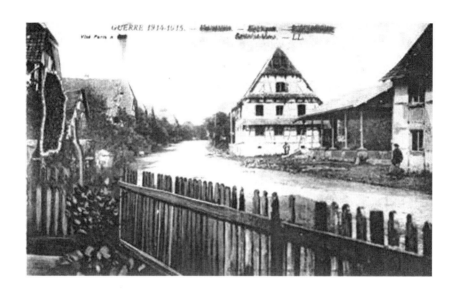

Tuesday 8th May 1918 cont . . .

I can understand Aunt Polly's feelings, but I can't follow Cissie's line of thought.
I think it's absolutely silly to go away & just return for 2 short visits before & then
silence for ever. Be sure I'd be bitterly opposed to such a course in anyone over
whom I had control or influence.

Hilda wrote a nice letter a few days ago. Unfortunately I'm some miles from
her—too many to wangle a visit I'm afraid.

By the bye the larger spoon was bought in a town now occupied by the Huns and
I ranged the same town trying to get the brooch in enamel. And the Huns are not
very far from the place where I got the violet roots, in fact they shelled the place
heavily about 4 or 5 days after I'd left. Are the violet roots luring yet? And the
ferns I sent in January or early February?

Cheerio darling,

Your loving husband,

Leo.

Friday 10th May 1918

My dear lassie,

Carrying on as usual this week but I am one of a party leaving here tomorrow
or Sunday. So please omit A.P.O.S.73 & simply address to the Coy, B.E.F.
France. I believe we are going to a very pretty bit of country but I must say
this place has suited most of us, self included. However we're not out here for
personal convenience + I've never yet been long in a place without settling down
tout de suite. The weather has been fine the past 2 or 3 days and old Fritz has
consequently been a little busy overhead.
Last night I heard a lecturer on "America's part in the war". It was well worth
hearing too. The lecturer was at one time in our Royal Marines but was a
professor of English Literature at an American University, when war broke out.
He gave some cheering facts about American efforts past and present and what
they hope to do.
Cheerio darling. I believe leave is starting. Many rumours are current.

Your loving chum,

Leo.

Sunday 12th May 1918

My dear lassie,

We left our camp on satdy morning; had a fine quick run for a couple of hours (quick comparatively that is) and after staying the night at a town where we had to change, came a few more miles this morning to this place. The country round about is a series of gentle rises and valleys and viewed from a nearby hill looks lovely in the fresh, green covering of spring. The violets in the woods on the hill are the largest I've seen in France.
I saw Tom G. when getting on the train this morning but stranger still; I met Fred Fripp (Fred Russell) in the town last night. Recognition was mutual and instantaneous. He made the same remark that Harold Brinaley did last Sunday–that I was the first fellow he knew that he'd met out here.

Love,

Leo.

Thursday 16th May 1918

My dear lassie,

Another bunch of mail in today. Two "John Bulls", yours of 28th April and May 1st, 3rd, 7th, and 10th; 1 from Dad, one from Jack C and one from Lebleu's. In addition I had one of yours yesterday dated 8th, with one from dad. So I have songs, words and music almost up to date. Of course (just like the time before) I've just got a green envelope away after hanging about waiting for a deluge of mail; still I have one or two green 'uns and I write another soon.

The last two days, including today have been sunny and hot as we have been outside most of the time and you'll know that we are rapidly developing the mulatto tint as Harold Pretty used to say. By the bye I'm writing him as your letters today are my first news re his wedding.

In the letter today Jeanne Lebleu mentions Hilda. She (Jeanne) would very much like to see Hilda and so I shall write both parties.

Cont . . .

Thursday 16th May 1918/2

Really one doesn't feel inclined to move out of the billet at night. The orchard, where we get our meals in the open, and where we parade is such a pretty place and commands such a view of the trees on the hill that at this time of the year it is a treat just to loll about and take things easy.

By the bye your letters today mention receipt of the spoons and brooch. I'm glad I got the second spoon and also that I got them away without delay. As things turned out it left me fairly short owing to missing a payday but I can manage all right for a few days and credit mounts up when one doesn't get pay. Will you let me know what you think of the small spoon?

Cheerio dear,

Your loving chum,

Leo.

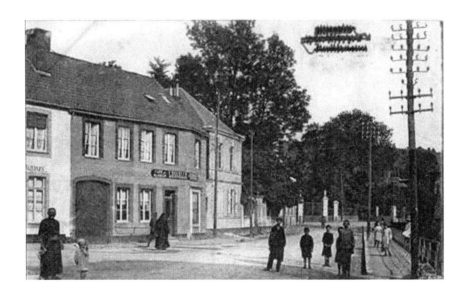

Satdy. 18th May 1918

My dear Chummie,

Whitsun eve I think it is. Don't know whether I'll be able to manage a
Communion tomorrow. I didn't manage one last Xmas day or Easter day so it
looks as though I'll go the year and miss all the special times. Still, c'est la guerre
and it is no fault of mine. I go when I can.
We are enjoying faultless weather. Glorious sunny days. Today I've been on a
job laying pipes. I'm sweating on keeping in the party as it's interesting and we
can make steady progress on our own. There were 3 of us and we all take a fair
share—no swinging the lead as it's in the open it's a case of stripping as the sun is
so hot.
I'm feeling champion; only want leave now to complete things.

Cheerio dear,

Love from,

Leo.

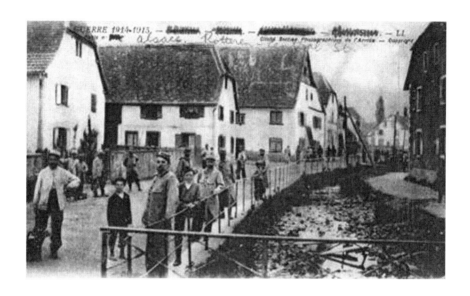

Tuesday 21st May 1918

Dear little girl, (Ilma—Leo's sister)

Some papers and 2 of your letters came today. Pleased to hear you did so well in the chick line. Let's hope they won't be old stages before the job here is "napoo-fini". So Annie liked the brooch. I knew she would. If she has had anything like the same kind of weather (at the seaside) as we are getting now she will be brown. Most of us begin to show brown faces.

I happened to be over today at the place where Tom G. is working. There's a nice piano and he seems comfy enough. Didn't get over to see Percy on Sunday went to the Y.M.C.A. and played for their service. Rather nice it was—a Scottish clergyman in charge. Thanks for the French Book item. I shall be glad to get it—I feel a little lost without one. As regards my not writing Pontefract—I was and am still writing a reply to the one I wrote in French to Aunt R. I suppose they have written and the letter is "lost or strayed".

Cheerio,

Very best of love,

Leo.

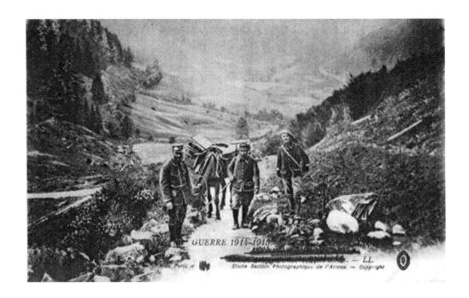

Thurs. 23rd May 1918

My dear Marie,

The parcel arrived today. Thank you very much for the contents, also for the promptness in getting French book. It seems like old times to be glancing at it and yet it is only a few weeks since I was busy on my old one.

The cake is nice and came in good condition.

Today is very windy but dry. Quite a contrast to the past few days which have been glaring hot. Last night a few of us had some very enjoyable cricket practice.

There is some good bathing too, down by the stream.

Think I shall go up to the Y.M.C.A. tonight. There's a good piano there (have played for last 2 Sunday evening services) and I need not spend the money I have not got!!

Cheerio dear; am in fine health and the job's still open air and O.K.

Your loving chum,

Leo.

CASSEL — Vue Générale

24th May 1918

Cher ami,

Nous avons bien recu votre letter du 27 avril adressee a Boulogne. Nous avons quitte cette ville le 6 et depuis lors nous sommes a Cassel (Nord).
Maintenant, resterons-nous ici? Dans tous las cas, je vous enverrai toujours notre nouvelle adresse.
J'espere que vous continuez a recevoir des bonnes nouvelles de Madame et de votre famille. Malgre les miseres causees par cette horrible guerre, nous sommes tous trois en bonne santé.
Presentez nos respects a Tom et recevez l'assurance de nos meilleurs sentiments.
Vos amis bien sinceres
Alice
(Translation.
Dear friend, we have received your letter of the 27th April addressed to Boulogne. We quit that village on the sixth and since then we are in Cassel (north). Now, are we going to stay here? In any case I will always send you our new address. I hope you continue to receive good news from your wife and your family. Despite all the misery caused by this horrible war, we are all three in good health. Give our respects to Tom and be assured of our best wishes.
Your sincere friends
Alice)

Satdy, 25ᵗʰ May 1918

My dear Marie,

I have had letters the past 2 days from Eric, Alan and Jack C. So I've quite a budget of war news. In addn I had one from you and one from Dolly W today. The mails here are regular again.

A few of us seem to have a touch of cricket fever as we find ourselves wandering down near the river on fine evening for a little batting and bowling. Quite an enjoyable change too. Yesterday was wet so I expect the trout in the river will rise well to a cheese bait tonight.

Sorry to hear Grannie is not so well.

Am still on the pipe job and like the job. Hope to stick for a while on these open air stunts.

Cheerio darling,
Love from Leo.

Monday, 27th May 1918

Dear little Chummie,

Glorious weather and an outdoor and interesting job—the same as last week. Yesterday my day was composed of work, sport and service. A few of us were at work till 12.30, and at night I went to the Y.M. service. In the afternoon a scratch team of the Coy. played a 2nd eleven of another R.E. Coy. at cricket. We found time to play 2 innings. Opponents batted first and made 13. 4 of our men were out for 9 but our 1st closed for 33. On their 2nd innings closing we had 16 to win and managed to put up about 48. I made 4 + 2. Went in 7th man 1st innings and opened 2nd. Played wicket keeper and found it o.k. Not a bad start as our bit of batting and bowling practice had been of a very loose nature but we'll back up now I fancy.

Cheerio darling. Keep a good heart.
Love from Leo.

P.S. payday y'day

Wed. 29th May 1918

My dear Marie,

I have at least one new item. Percy was relieved yesterday on a pumping job and retd. to camp last night, so once more we have swopped notes.
Today we have had our parliamentary register cards distributed and have filled same in. Blessed if I can remember whether 36i is in B'ham South or Edgbaston Division—I mean whether it is B.S. or Edg. as the name of the constituency.
There is a band playing by the river tonight—and a footer match to be played. Grand evening with cool breeze. My foot is busy tapping to the time of the band as I write. Still on the same job—picking up any tips of course.
I am trying in future to send one or two cards better illustrating the pretty scenery here.

Love from

Leo.

Friday, 31st May 1918

My dear Marie,

Still glorious weather and outdoors on the pipe job to enjoy it.

There are rumours of lists going in for leave; also re a starting again of leave in June. I mention this only casually as I only know them as rumours. Our cricket ball has burst seams so the past 2 or 3 days we have not been down for any practice. So I've utilised the time with baths, washing clothes and a few sundry items. I am pleased you had such a nice time at Kidder. You evidently had grand weather bar the thunderstorm.

Jim Lythgoe is here (sleeps in a little place holding 6 of us) so is Cpl. Dodds (in the same 6) so only Jolladay is missing from the 4 of us who were in the wood. Percy is here (and I hear that Tom G. may be here tomorrow) so quite a lot of old 196ers. are together. Jim is just as cheery and pleasant as ever.

Cheerio dear chummie, your loving husband, Leo.

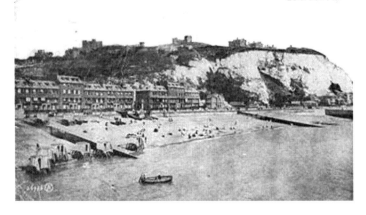

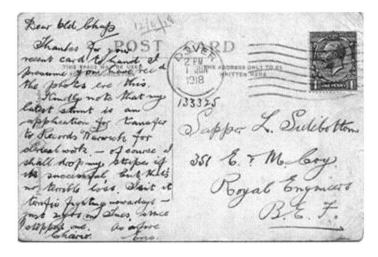

Postcard from Leo's brother Eric

1ˢᵗ June 1918

Dear Old Chap,

Thanks for your recent card to hand, I presume you have rec'd the photo's ere
this. Kindly note that my latest stunt is an application for transfer to Records
Warwick for clerical work—of course I shall drop my stripes if it's successful but
that's no great loss. Isn't it terrific fighting nowadays—just 2 years on Tues since I
stopped one? (A bullet)

Cheerio As afore

Eric

Sunday, 2nd June 1918

My dear little girl,

This card (possibly these cards as I may write two) gives you the nearest idea I can of the nature of the scenery here. Incidentally there seem to be more pastures than is common in the parts of France I've seen.

The weather continues sunny with nice breezes. We have had our rifle inspection this morning and as we have a day off the pipe line job (our first since we started) I am going with another fellow to 10.30 Communion all being well.

I am feeling as fit as a fiddle, due probably to open air work. Our present place of work is on the top of a gentle rise in the country and the hot sun is just tempered with occasional breezes. So we are "feeling" brown but not done!!

Cricket again this afternoon.

Cheerio darling. Your loving chum.

Leo.

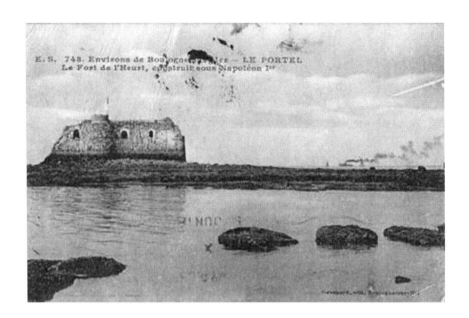

3rd June 1918

Cher Leo

Je viens de recevoir a l'instant votre letter du 17.
Je vous remercie beaucoup et vous ecrirai sous peu.

Meilleurs amities

Jeanne

(Dear Leo,

I have just received your letter from the 17th. I thank you very much and will write soon.

Best wishes

Jeanne)

Tuesday, 4th June 1918

Dear little girl,

I seem to be in lucks way lately. Today; whilst up on the pipe line job I met Ernie Jackson from Heysham. He is a Corpl. In the E.Yorks & was transferred to E.Y. from the Kings Own. He says he has met recently, round here, Jimmy Gray, Harry Waters & Herbert Pilkington. I am meeting him tonight at 6.30.
We played another match on Sunday & won rather too easily (117 to 23). I played wicket again, was caught out for a duck!!
So you have news of Alan being marked A1 again. Well don't anticipate trouble. Don't meet it halfway. Plenty of things can turn up to ease your minds.
The pipe job is almost finished. It has been interesting to me and the weather has been glorious. I only hope I "click" for more such jobs.

Cheerio dearie,

Your loving chum,

Leo.

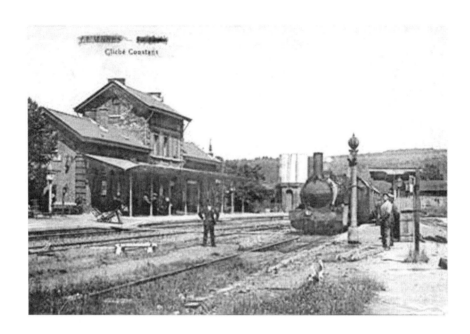

Cliché Constant

6th June 1918

My dear Marie,

I had ppc's yesterday from both Eric and Alan. Alan's seems to suggest being in a draft ere long but I do hope you at home will not be too anxious. I know what you feel like.

Ernie Jackson and I have been out together the last 2 nights & I am going tonight with him to some sports nearby, Mile races we are promised, so there should be some fun. We have talked Heysham and Morecombe nearly all the time. He is writing to Eric.

Glorious weather continues. The piping job is finished pro tem as far as I can see. Ernie expects to leave in a day or two. It has been a real pleasure to both of us. Very sporting lot of Infantry about here lately. A couple of nights ago it was possible to see polo, cricket, Rugby and football in progress at the same time in the meadows by the river.

Cheerio dear chummie, I am feeling fine,

Your loving husband, Leo.

Tuesday 11th June 1918

My dear chummie,

I have nothing new to tell you.

Work—as usual
Health
Cricket
Weather
Leave

The roses round the farmhouse here are in bloom. Some rain yesterday freshened & sweetened everything. Today is nice again.

Really am absolutely stumpted for news tonight. So cheerio dearest.

Best love,

Your loving husband,

Leo.

Thurs 13th June 1918

My dear little girl,

Just to vary the cards, here is an Italian one which I picked up in a shop here.
There was a selection of rather nice ones.
I am going easy at present as I want to send you a postal order next week.
Fine weather continues. We finished our pipe job yesterday and 3 of us have been
on cook's fatigue today. Quite a change. After this business I think you'll have to
go out to work whilst I get the dinner etc ready and do the washing and attend to
the (prospective) fowls and the (anticipated) allotment.
I haven't had a letter from you since Satdy. So I expect there will be one or two
in tonight's mail. Am busy on French again—a little each evening. You may be
interested in the enclosed cards recd. lately from my civi friends.
Cheerio dear,

love from,

Leo.

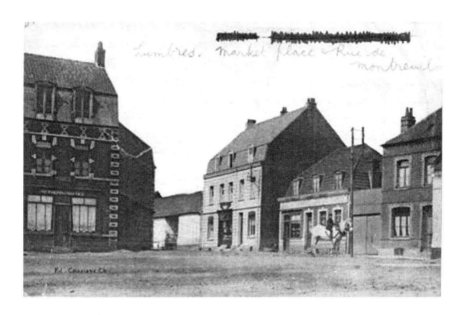

Saturday 15th June 1918

My dear chummie,

I rec'd the "Visitors" and a letter from you last night—the first since last Satdy. Pleased to hear you had such a pleasant time at Four Oaks. Rather a large house I guess.

So very pleased to hear Eric's transfer to Warwick is already accomplished. He will be better able to look in at home occasionally though he'll miss the sights & doings of Dover town.

So Florrie B. & Fanny D. are going to Morecombe this year. I do not think I'd like to go while the war is on. There would be something lacking. I'd much rather meet the boys out here. Of course I say nothing about visiting dear old Brum—but the leave is evidently not yet to be. Am now waiting further news of Alan. Cricket practice continues & we get some nice exercise at it.

Cheerio dear,

Best love,

Leo.

Monday 17th June 1918

My dear chum,

I have once more landed on office work but this time it is only on duty at certain odd hours & the main part of the day shall probably be out of doors. Glorious weather but the job will keep me from evening cricket this week I expect. I wasn't able to play yesterday owing to being out of camp till nearly 5pm. We played the same team as the previous Sunday & yesterday they won by 8 after a sporting game. I don't suppose I'll be playing wicket now though as one of my chums who according to accounts is a fine "keeper" has come into HQ today.

Rather nice that Eric got home whilst Alan was there.

Sorry to hear of Capt Jones & Ernest Butler, 2 more families! And the former has been out since '14

Cheerio dear chum

Love Leo.

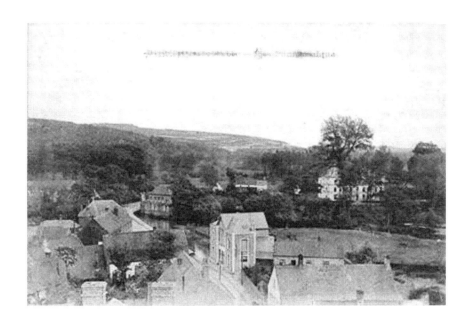

Wednesday 19th June 1918

My dear lassie,

Percy & I had some fun fishing in a little brook this afternoon. I didn't catch any but he had 2 nice little trout when I left & a third one before he left. It is a fine little stream and very clear. On approaching the little pools here and there one can sometimes catch sight of the fishes. The weather continues to be enjoyable. Your letter from Four Oaks arrived yesterday. Pleased to know you have dined so well & and made new acquaintances.

I am so very sorry to hear of Albert Warbinton being killed we were such chums and until I lost his address through a change in name, I corresponded fairly regularly. He is another of our old C.L.B. who has proved what our Coy. was worth, we who remain have a sort of quiet joy in the way our C.L.B. has acquitted itself. I note what you say about the P.O. Bank. I thought of it after I'd written. Let it go for the time being.

Cheerio dear chummie,
My best love,

Leo.

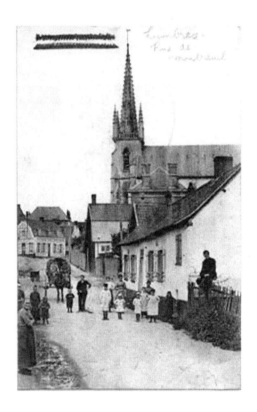

Friday 21st June 1918

My dear Chummie,

Very little to write of at the moment. Percy & I have done a little fishing on each of the past 4 afternoons but beyond his 3 trout 2 days ago (which we had for supper) there has been nothing doing though we've been unlucky in fish getting loose from the hook.

At present we seem to be hanging on for another move, so I expect we'll be leaving this pretty place. Heard from Hilda today and she seems pretty busy with Plays, dancing & bathing in spare time. She seems pretty well.

You'll remember that some months back Parliament made certain increases in Soldiers pay. At first we heard that specially enlisted men (as we were in our old coy.) were outside it but now I think we shall participate.

Love from Leo.

Sunday 23rd June 1918

My dear Marie,

We may move anytime now from here as far as I can see, so I have bought 4 of the Italian cards you like & enclose 2 of them. As soon as we know how things are going I'll send the promised P.O. order.

What a queer week it has seemed in your letters. Now I hear of poor Aunt Kate's death. The last time I saw her was in Aug last. Uncle Jim will miss her very much. Sorry to say I can't give you further news of leave yet. One or two fellows have gone this week but it seems to be semi special in their cases as they are time–expired and get a month (Territorials)

Will endeavour to write a green 'un soon. Meanwhile cheerio dearie,

Keep smiling.

Your loving husband,

Leo.

23/6/18

Italian card as mentioned in previous postcard.

To Marie from Leo.

Wednesday 26th June 1918

We struck camp on Monday & have now settled down for the time being at an R.E. Base. Many speculations as to future happenings & movements but no-one of course can do any more than guess.

Meanwhile—its fine weather for which (being in tents) we are thankful as it is so messy otherwise.

I enclose the other two Italian cards. Please forgive this one being so smeary—it has rubbed against the other "Italians"!!

Nothing more at present except that I must try to get the green env. away in the next day or two.

Your loving chum,

Leo.

Monday July 1ˢᵗ 1918

My dear lassie,

Percy and another & myself had a fine time yesterday. We each managed a pass
& spent from 3.30 to 8pm in the town. The buildings are much the most ornate
I've seen so far in France. We had a look round the Cathedral & then walked up
to the museum. It is a fine place—mainly of natural history items—stuffed beasts,
bird, reptiles & fishes. There is also a representative collection of skeletons & to
see one case with the frames of men & Gorilla's side by side makes one look for
the difference—which isn't much!! There's a full size skeleton of a Rorqual whale.
We had a stroll round the streets after tea. I was very much impressed with the
place. It's the first really big French town I've had a look round.
Cheerio and best love,
Leo.

CATHÉDRALE DE ROUEN. — Intérieur.
Inside of the Cathedral.

Wednesday 3rd July 1918

My dear little girl,

Yours of 29th came tonight. We are still enjoying fine weather. I've had a rather
bad cold in the head for 3 or 4 days and a slight headache today but I think the
cold is going now.

I am sorry to say that leave seems remote as yet. My cold has made me feel
properly fed up and unsettled since it came. Sorry to hear the news re Alan, I
hope it didn't upset mother.

I am at present on office work. There isn't a great deal doing & perhaps as well
while I'm off colour. Being down at the Base has made one difference. We have
had to be regimental, Buttons etc polished, kits outside tents on fine days etc.

As I write the gramophone here is playing selections from our play "The White
Garland"! It brings memories of the success we had at St C. School.

Cheerio darling, best love,

Leo.

ROUEN — Statue de Napoléon
Statue of Napoleon

2/ Tuesday 9ᵗʰ July 1918 cont . . .

has the new malady. So glad to hear the rosetree of mine is looking so well–of course it is only mine in name now. But what about Mr Matthew's remark when I planted my first rose trees–they don't seem to do so well around here!

So the Baileys are still O.K. (in civi. togs) Would you have liked to marry a shirker? I am feeling much better today, only a slight touch of my head cold remains. I'm busy now on a trench again. Am managing well in the effort to cut down my smoking.

Cheerio & very best love,

Your loving chum,

Leo.

(The new malady Leo refers to is almost certainly the influenza epidemic that began in 1918 and eventually killed 20 million people worldwide.)

Thurs 11th July 1918

My dear Marie

Thanks for yours of 8th from Kidder. I am feeling much better—only cough remains & that is troubling me less each day. Re Alan, I made enquiries here & found he would be likely to come here. So yesterday after tea I went to the same office, to the Orderly Seargt. & he showed me the list of arrivals with Alan's name. Two mins. later I found Alan. His tent is about 2mins. From our camp!! Lucky eh? He looks well & is in good spirits. I shall be out with him tonight.
I am so glad to know that you are so keenly attached to mother & she to you. It makes it easier for you both & proves that it was a good thing when you moved to R.P.Rd. definitely.
Glad to know still getting the War Certifs. They are worth accumulating.
Cheerio darling,
Leo.

I have had a lot of S.A. envelopes given.

(Alan is Leo's brother)

C. P. - 514. - ROUEN. - Rue des Matelas

Satdy 13ᵗʰ July 1918

My dear Marie

As I am uncertain of the date you leave Kidderminster so I am sending this to Brum. Yours of 9ᵗʰ arrived today & I note Hilda has been in hospital with gastritis. I hadn't heard from her. Glad to hear of your little purchases in Kidder. Also thank Grannie from me for her gift to you & I.

I didn't know Mr Matthews had an allotment. I suppose he is definitely rejected as regards the Army. Alan came round on Friday morn. to say he was leaving that aftn. for the 16ᵗʰ Warwicks so I went round after dinner & saw the parade ready to march off. He looks very fit & is as lively as ever. We are expecting to move off any time and it wouldn't surprise me if I drop across him.

Cheerio, love from, Leo.

Sunday night 14th July 1918

Dear lassie

We are leaving here possibly tomorrow. Have had another very nice time in town with Renay & Don Gardner.

Cheerio & best love,

Leo.

Satdy. 20th July 1918

My Dear Marie

I had a short letter today from Alan and he appears to be fit & well. He mentions being in C Coy. 16th Warwicks. I also heard from Carruthers.
Yours of 13th & 15th are to hand. You'll be glad to know I've shaken off the cough & cold. We can get good milk here & of course I'm indulging, but I think I sweated the cold out on the journeying.

Since we arrived here I've been doing a bit of clearing up in the office as things naturally got upset in the travelling. Not a great deal to do and, waiting for our new camp to be fixed up we are rather cramped. So (cont . . .)

131. ROUEN
Fontaine de la Croix de Pierre sur la Place de ce nom
Croix de Pierre fountain on the place of the same name

20/7/18 cont . . .

I have to clear out for a bit when there too many in the office.

The village here suits me. Pretty scenes along lanes and there are some woods and a river. So we shall peg along comfortably. Thank goodness we are quit of our late camp, where we had dust inches deep on the tent floors.

Renay & I are doing a bit of exploring the countryside each night.

Cheerio & very best love,

Your loving husband,

Leo.

Monday 22nd July 1918

My dear lassie,

It came as a pleasant surprise to me when I found Alan so <u>easily,</u> but I can
imagine your joy when you heard that the possible had become an accomplished
fact. What did we talk about—why little else but commonplaces—how they all were
at home, etc. Commonplaces—but we've little room for other items. Strange as
it may seem I took it all for granted, and somehow never fancied how easily we
could miss each other.

Last night we had a walk to the nearest fair-sized village but 20 mins. was enough
for us—we quitted the place without any apparent interest.

Cheerio dear chum,

love from,

Leo.

Satdy. 29th July 1918

My dear chummie,

Received today your letter saying you'd returned home. Glad to hear you had such a pleasant time in Brum.

How do you like the view on this card? You'll see the statue of Napoleon on the right hand side of the picture. We had a good look round all this part.

The weather is doing it's best to bring on the fed-up feeling lately. It generally rains hard at mealtimes and we haven't a mess room or even temporary shelter at present. Consequently when we get a meal served out without gravy say (not home gravy of course) it is in the form of soup by the time we get through. Few of us think it's a lovely war!!

I am thinking of taking (cont . . .)

(2) 27/7/18 cont . . .

up Pelmanism. Percy is also considering it. If I do, I may get the course out of my pay (by instalments) or write home for the money. I'll let you know but I think it will be by instalments.

I can't yet give you any definite news of leave as of course we are only just getting into swing in our new job. Am on the office job still but can't say that I find it very enjoyable or interesting. Fact is the leave question makes me fed up.

Well, cheerio dear lassie. Keep smilin'as long as you can,

Your loving chum

Leo.

Heard from Ernie Jackson yesterday.

(The Pelman Institutes of England and America apparently once claimed over half a million followers. It was a self improvement system based on improving memory using mnemonics, surviving now as a memory card game, although there are occasional attempts to revive it as a commercial correspondence course.)

ROUEN. — Le Pont Boïeldieu et la Cathédrale.
Boïeldieu bridge and Cathedral.

Monday 29th July 1918

My dear Marie,

Your letter of the 23rd came yesterday and a jolly fine one it is. As it happens I am writing this while doing a bit of fishing (my first in this part). Percy came down today & landed a very nice trout. I managed to get hold of a hook so I'm now awaiting a response on the part of ye fysh.

I had a letter from Hilda. She told me all the news, including looking forward to leave in about 9 weeks from now. She asks me whether I was likely to get it then but I told her not to hope for that. I'm too fed up, "grousy" on the leave question. It's like that line in "Kathleen Mavourneen."

Pleased to hear you had a good time with mother in town.
Rather funny that Alan (cont . . .)

("Kathleen Mavourneen" is a song, written in 1837, composed by Frederick Crouch with lyrics by Marion Crawford. It was popular during the American Civil War. "Mavourneen" is a term of endearment derived from the Irish Gaelic mo mhuirnín, meaning "my beloved." The penultimate line of each of the two stanzas of this ballad of separated lovers is: "It may be for years, and it may be for ever.")

129

(2) 29/7/18 cont . . .

didn't mention much about our meeting but take it from me that we both enjoyed it. There are some fine forget-me-not's on the bank here—I enclose some of them. Since I wrote on Satdy our arrangements for meals are better: we now have meals brought to our billets so that it doesn't matter so much about the rain. The weather is better—it seems to have changed to fine days now.
I got the particulars from the "Pelman Institute" and am going to take up the course. I'm sure it will be worth it. Percy is considering it.
Will write again one this week,
Cheerio dear,

Your loving chum,

Leo.

P.S. 33 months today!!

Wed. 31st July 1918

My dear little girl,

I've been out tonight & got some mushrooms. There seem to be plenty about here. I've also been fishing two nights this week but it isn't good weather for some as the days have been very bright since Sunday.

Things are going on much as usual as regards myself. Am still on the office job but not much in love with same, especially as we are cramped for room until we get our new place fixed up.

Thanks for "John Bull. By the bye I've definitely made my mind up re Pelmanism & shall start at once. I will give you particulars in the

501. ROUEN — L'Eglise Saint-Maclou
et Vue d'ensemble sur la Vallée de Darnétal, prise de la Flèche de la Cathédrale

2/ (31/7/18 cont . . .)

green envelope I hope to write this week.

Yours of 25th came yesterday. By the way how many hens did you get out of that first sibling? Do they all crow!!!

I notice the B'ham strikers have ret'd to work. I wonder their ears burned. Rather a propitious time to strike—while the French push was in full action!

Mrs Cooks letter came yesterday. She refers to B.B's wedding but her opinion of B.B. is not at all complimentary.

Cheerio dear

Your loving chum,

Leo.

ROUEN. — Le Grand Marché. — Un Pavillon. — The Great Market. — A Villa. — LL.

Thurs 1ˢᵗ August 1918

My dear father & mother,

Thanks for letters which are very regular. I have yours of 10th, 17th & 24th here. I wrote on 19th so must have missed one then. There is nothing in first part of yours of 10th but later you refer to Mr Carr's run of ill fortune. They certainly have had a very bad time. Is Mr C. still in Rotton Park V.T.C.? I wonder if he remembers my 8 months in it? All that seems far away now. We seem to be absolutely settled here, after 32 months. I tell the French people here that I shall have a fine beard before I get my discharge from this lot.

Yours of 17th is a regular book of letters, with a little from each of you. (contd.)

C. P. - 321 - ROUEN. - Le Jardin des Plantes - La Vieille Maison

1/8/18/ cont . . .

Re that Corpl. in R.F.A. who is a M. Medallist. His opinion is mine on some items.

I knew mother would be delighted at my meeting Alan as she wouldn't think of such a thing happening. It all seemed so natural considering the place & the time we were there, that one fails to think that there are millions of us out here. Of course the main item is that I was prepared by knowing the approx. date of his leaving England.

Yours of the 24th. I think you have had a representative lot of views of our late place. I have just a few left. They seemed more interesting than (sic) village views. So Alan is in charge of a L. Gun detacht. By the bye I forgot to mention that when I saw Alan I also saw a young fellow called Millington. You know his father.

Cheerio. Best love,

Leo

70. ROUEN — Le Gros Horloge. Façade Occidentale
The big clock. Western front

Sunday 4th August 1918

My dear little girl,

Today of course is <u>the</u> great anniversary. It is really questionable whether 1915-16 or '17 were as great as this one, as the great impetus of American effort is making itself felt now. The Allies are having a very propitious time at present, In the west the Huns are having an anxious time—in the East the murders of Mirbach and Eichhorn, the Murman coast landings, Japanese movements & the necessity for a German-Finnish offensive indicate that all is not well for them. In the South the Austrians have had a bad time in Italy & Albania. To my mind the Huns only hope is a recruitment of Russian labour or fighting forces for the Army. That is our one real danger I think and of course it is a risk (worth taking!) to the Huns as you can imagine. Today we had a Church parade but as it was sandwiched between work finishing (12 noon) and a rifle inspection at 2pm it was

ROUEN. — La Rue de la Grosse-Horloge. AD. Phot.
The street of the big Clock.

2/ (4/8/18 contd)

about 1pm when it ended.

Then we could not stay to Communion—which is difficult to manage here—as we
had to get dinner. & clean up rifle &c. between 1pm & 2pm. And yet an appeal
for us to stand by ideals & the man with ideals generally exercises an influence
for good over his pals, though he doesn't brag about it. Small wonder that fellows
grow careless. I enclose the service paper.
Whilst we were at the Base I mentioned going under an archway where there
was some fine stonework. I managed to get a p.p.c. of the work. These two cards
represent the street running under the arch. In the one showing cathedral in the
distance you will partly see under part of the archway. The next card I send will be
of the carving under arch so the three will go together. Beautiful day today,

Cheerio darling,
Your loving husband, Leo.

ROUEN.
Dessus de la Voûte de la Grosse-Horloge.

Tuesday, 6th August 1918

My dear Marie,

I promised to see the card of the under side of the arch. As far as I could see it was a representation of the "Good Shepherd." You'll see for yourself.

Things are a little better now as we have moved into part of our new place & it's roomy. I'm still squaring up things a bit in the office.

I had a letter from Alan yesterday. It was dated 7/7/18 tho' I didn't notice that at first. What I did note was 5th Warwicks & I couldn't make it out at first until I noted the date & then remembered that when I saw him he said he had written to me. And it's just turned up.

Heard from Hilda & she seems to be o.k. again.

Cheerio. Very best love,

Leo.

BON-SECOURS (Seine-Inférieure).
L'Eglise Notre-Dame.

ND. Phot.

Satdy. 10th August 1918

My dear Marie,

You will remember that in writing of our last Sunday before we came to this place, I mentioned a visit to the little church on a hill which was as ornate as the cathedral. Well, you will be able to judge for yourself from these cards. It is a modern building. You'll notice the decorated pillars inside the church. Later on I have one or two more to send of the carving etc. That afternoon we had a fine time for we saw this church, the Joan of Arc memorial & had a fine tram ride up a steep hill & cliff face.

This has been a red-letter week for the Coy. First there was our inspection by the Major—Genl (not Genl). Then yesterday night we were warned for a parade today which turned out to be one for lining (cont)

BON-SECOURS (Seine-Inférieure),
Nef de l'Église Notre-Dame.

2/ (10/8/18 contd)

part of a road when the King passed.

We have also heard a rumour of leave starting soon, but the source I heard it from is by no means reliable so I think we had better not build up our hopes until I can tell you of an actual start.

We hear a rumour that our O.C. is leaving. He has been my O.C. since I joined the Coy.

It is 7pm. A beautiful evening & consequently not an ideal one for fishing, though I have the line. Great for a long walk, dear chummie.

I enclose Harold Shepperd's latest letter. It will interest you.

Cheerio & best love,

Your loving husband,

Leo.

Thurs 15th August 1918

My dear Marie,

A year ago today I was just commencing leave. There are rumours now floating round of leave for our Coy. reopening but so far they have failed to materialise. We are having grand sunny days with beautiful evenings and it is a treat by the river at night. I take the line but generally am writing instead of looking at the float.

This card shows some of the carving I mentioned. I don't remember ever seeing figures so well carved as well as these. They are lifelike. Supposed to represent the 4 evangelists I believe. You'll notice this is in the church with ornamented pillars Cheerio,

Best love, Leo.

Satdy. 17ᵗʰ August 1918

My dear Marie,

How do you like this view, as a variation of those I've been sending lately? It gives a fairly good idea of the fine outlook we had from the top of the cliff.

Well now one of our Coy. has gone on ordinary leave today & another one goes tomorrow so a start has been made. O.K. eh? Hope it keeps on the move now as I'm not far down on the list.

The Pelman papers (1ˢᵗ of 3 courses) arrived yesterday & last night. I put in a couple of hours at no1 booklet. I found it very interesting. As I'm persevering with French verbs I've plenty of items to occupy spare time.

Haven't heard from Hilda for some days, nor Alan. Your letters too have been missing for 2 or 3 days—I expect they'll come together—they've been regular since we came here.

Cheerio dear lassie,

Love,

Leo.

Église Saint-Maclou, Porte de Jean-Goujon.

Monday, 19th August 1918

My dear Marie,

33 months today since the old 196 Co. landed in France.

Thanks so much for the parcel that arrived in good condition this morning. I haven't got your letter covering same as yet but perhaps it will be here in the morn. as yours of 14th came today, with dad's. Please thank Ilma for the book. I heard from Alan today. He mentioned a move but I believe he's still in the same formation as myself.

This morn. sent you a small piece of crested ware which I bought at a shop opposite the Bon Secours church of which you have the p.p.c.s.

How do you like this p.p.c.? Good isn't it?

I am sticking well at Pelmanism & French.

Cheerio best love,

Your loving husband, Leo.

Wedy. 21ˢᵗ August 1918

My dear lassie

The parcel was very nice indeed & the boys of the billet had a slice each of the cake—quids in.

I have finished my first Pelman sheet ready for sending off.

Thanks very much for the list you sent for Septr. Glad you fixed it up.

No more have gone on leave yet but we are hoping to record more any day.

Glorious weather at present so we are indulging in the river a fair amount.

Very pleased to hear Aunt Rennie is to pay you a visit. Make it a happy one dearest.

Your loving chum,

Leo.

ROUEN. — L'Abside de l'Église Saint-Ouen. ND. Phot.

Friday 23rd August 1918

My dear Marie,

Just a few lines to say I'm still carrying on as usual. I hope to write a green envelope tomorrow night or Sunday. Had a fine walk tonight & a jolly good feed on blackberries.

Your loving chum

Leo

SAINT OMER — Salle de Concerts - Place Saint-Jean

St Omer, le 26 aout 1918

Bien cher Ami

Etant a St Omer pour quelques jours, Je vous envoye toutes mes amities et
meilleurs souhaits. Je suis chez ma cousine que vous avez vue a Bailleul; elle
est refugee ici avec son pere. C'est a elle que J'ai eu la carte de P.D.C. et Je
m'empresse de vous l'envoyer aussitot. Je retournerai demain a Ebblinghem. Papa
et Maman sout en bonne santé ainsi que moi-meme et J'espere qu'il en est de
meme avec vous. Presentez a Tom mes meilleurs sentiments.
J'attends de vous une lettre en reponse aux miennes. Toujours votre amie Alice.

(Good dear friend,

Being at St Omer for a few days, I send you my best wishes and hopes. I am
staying at my cousin's that you saw in Bailleul, she is a refugee here along with
her father. It's from her that I got this card of PDC, and I will send it quickly.
Tomorrow I will return to Ebblingham. Father and mother and I are well and
hope you are too. Give Tom my best wishes. Waiting for a letter from you in
response to mine. Always your friend Alice.)

BON SECOURS (Seine-Inférieure). XII. Phot.
Le Monument de Jeanne d'Arc. — Jeanne d'Arc statue.

Tuesday, 27th August 1918

My dear Marie,

Voici la dernier carte de R. Je pense que vous agreerez que je vous envoye' une belle collection.

"Here is the last card from Rouen, I think that you will agree with me that I have sent you a beautiful collection."

No further news of leave as yet. I suppose the two usuals will turn up at the weekend.

I heard from Mother at 97 today. Her card & letter have been retd. As insufficiently addressed to me. I'm glad she wrote after all for my birthday.

I am about half-way through my 2nd Pelman sheet. Am still pegging away at French & have long ago passed the Aug. limit I set myself.

Cheerio dear,

Best love, Leo.

Thurs. 29ᵗʰ August 1918

My dear lassie,

As you'll see I've finished my R. postcards & shall have to fall back on books again.

The weather is some-what colder and wetter but not too bad. It seems to be improving.

Last night some of us went up to a range & did a little firing, Just a preliminary practice to ensure that we are O.K. & that the rifles are not a mere ornament. Just as we were inspected, two or 3 weeks ago—for general smartness & efficiency.

As one of the fellows before me on the leave list has gone away it has helped my chance a little.

Cheerio, love,
Leo

This card shows a scene from St Omer—possibly provided by Alice? There is now a gap of several weeks—presumably coinciding with leave—and the character of the ppc's changes from specific scenery to more generic 'war' cards.

Tues. 22nd October 1918

My dear sweetheart,

We are not allowed now to send p.p.c.s of places in the army areas but I am
hoping to send you a representative collection of different French style cards. Here
is one of the Heavy—artillery men—French army of course.
Thanks for the John Bull & yours of 17th. I don't wonder the days have seemed empty.
It is due to the very full & happy days we had. The best of all 3 leaves it seemed.
I know you'll write as soon as you have news of Eric or Hilda.
The weather is dull & mud very plentiful & with the nights being on us after tea,
say 5-30, there is really nothing doing so I' making up my programme by settling
to the things I want to learn.
So glad you are taking care of yourself my dear little girl. By the way have you seen
the reference to increase of separation allowances?
Your loving husband, Leo.

Thurs. 24th October 1918

My dear lassie,

I am writing a green env. soon—to arrive of course for <u>our</u> anniversary. Meanwhile thank you for the "visitors" and more particularly for news re Eric. I think myself it's too rough but there is no way out of it, save the maximum of cheerfulness. Perhaps I'd better go warily & say that the weather has somewhat improved. It has such a habit of cutting up rough if one says it's fine!
Rumours of moving—but only rumours so far. However you might please send me the size of that finger.
Your loving chum,

Leo.

This card is, so far, unique, as it is typed.

Sunday, 27ᵗʰ October 1918

My dear lassie,

3 years today since Percy & I enlisted, and he marks the day by leaving here for the Base for leave. Three years on Tuesday since . . . eh

I suppose Hilda will be with you at present? At any rate I haven't written her since my return, on that supposition.

So glad to hear that the photo was such a success. I think we might have 3 cabinet style as well as the postcards, so that we two can have one and give one to each home—what do you say?

My cig smoking decreased considerably last week—but I should mention that it was on account of a great scarcity. We are now getting them again but I think I can continue the habit of smoking less.

How do you like these cards?

Cheerio dear. Your loving chum, Leo.

To my darling wife,

I wish a happy anniversary of Our Day—29th October.

Your loving husband,

Leo.

France 25/10/18

Thurs. 31st October 1918

Dear Little girl

Thanks muchly for the Pelman books, also John Bull & yours of 24th. Very glad to know Hilda is at home, also the better news from Eric.

How do you like this card? It is really typical of the men who guard the railways. Middle aged men generally with a busby moustache.

What do you think of the real progress each week records now? Note the end of a week & compare it with the rest & you'll see it—political as well as military.

Every thing here as usual—going on with French etc.

Your loving chum, Leo.

Tuesday. 5th November 1918

My dear lassie

Things are about the same. Have had a fine hot bath today & I feel A.1. How do you like the cards I'm sending? We have had a stiff argument tonight about the biggest eng. works in Brum. We can't agree!

Did you see the demobilisation scheme mentioned in Sunday's (& I suppose Monday's) papers, Evidently somebody knows something—though an M.P. says we could have probably settled the war this year if we had had 5 more American Divisions at one time this year. <u>This</u> year hasn't ended yet has it?

Cheerio,

Best love,

Leo

Note—Armistice Day passes without any communication.

Monday. 18th November 1918

Dearest lassie,

I have replied to Mr. Perkins and have asked him plainly whether my old job is open at Tangyes, or another one. If his answer is favourable it means that I stand a so much better chance of early discharge than if he can't definitely promise a place at one.

We have had very keen frosty weather for a week or so, but very sunny days. Today, however, it is trying to rain.

Things seem at present to suggest "little doing". Our working hours have been shortened by an hour and a football team has been started. There is a meeting tonight re a concert scheme.

I went into town again yesterday aftn. The place is slowing resuming its natural activities & beyond the change of scenes it doesn't offer much inducement after one visit.

Cheerio.

Very best love,

Leo

Thursday 25ᵗʰ November 1918

My dear lassie,

Just a few lines to keep in touch. I'm pretty fit & well, thanks to individual effort—our best of the day being porridge which 3 of us make for supper. The rations lately have been very poor & at times badly cooked. We don't mind plain meals but bar poorly cooked meals & little at that.
Just at present I am held up a little in my studies and as we are now starting concert practice in earnest (having fixed up a large hall & a piano) it looks as if I shall have to cut something else down, for studies.

Cheerio darling, your loving chum, Leo.

A portrait of Percy with whom he joined up (see diary at beginning)

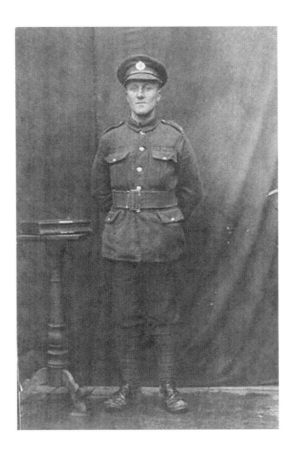

Annappes, nr. Lille
26th Novr 1918

Lille
La Grand' Place

Satdy. 30th November 1918

My dear lassie,

By the order I mentioned recently, I am now permitted to tell you that I am at
Annapes, an hour's walk from Lille, we are permitted now to mention the place
& surroundings, & the restrictions on p.p.c.s are also cancelled. So I hope to
re-commence a selection of views. Sorry this is a German printed one. You'll
understand that for a few weeks after the liberation of Lille it is a case of German
printed ones or none at all. And then it is helping the civies pro tem as they have
stocks and need money. So needs must etc.

Cheerio dear,

Love from

Leo

Tuesday 3rd December 1918

My dear sweetheart,

Here's another view of Lille. This fine building is in the Grand' Place. I understand it is the old Bourse. Hope to send more later.

Am just about fed up with most things. We keep on rolling along. I suppose we'll just have to put up with another Xmas day out here. The last one as far as we know. How I'd enjoy this one with you.

Meanwhile the next best thing to discharge is preparation for civi life so I'm sticking at my studies.

Cheerio.

Love,

Leo

Sunday 8ᵗʰ December 1918

My dear lassie,

Just a line or two to say I've read yours of the 3ʳᵈ inst. & am glad to hear of your getting better. Long letter soon.

Cheerio,

Love, Leo

Thurs. 12th December 1918

My dear chummie,

We had a bon night last night, at the concert in Lille. Except that the actual number of seats seemed smaller, the theatre was after the style of English theatres of the better class.

On Tues night there was a general meeting & as the Xmas arts. promise to be much better than last year, I'm giving up the Boulogne idea at present.

I shall write a long letter tomorrow all being well, as I expect a letter from you then. You'll notice by the bye that the present p.p.c.s are all of big towns.

Cheerio, Love,

Leo

Tuesday 17th December 1918

My dear lassie,

Thanks very much for "John Bull". Quite a batch of papers came today from Edg.
Rd.
This photo is of the village we are in. Our place isn't far from the church.
As regards demobln. am not very optimistic about release so early as say next
month. I am sweating on 2 or 3 months at the least. A lot will depend on the next
few weeks—one can't say how soon general demobilization will come. The sooner
the better—so that one's energies can be devoted to self-advancement and so that
one's energies can be used fully again. At present such isn't the case.

Cheerio dear.

Your loving husband,

Leo

To my darling wife Marie,

With loving greetings and high hopes of a <u>happy reunion</u> soon.

From your loving husband.

Leo

France.

Decr. 19th, 1918

Sunday 22nd December 1918

My dear lassie

The Sunday before Xmas. In normal times before the war we'd have been looking forward to the 25th. Since 1914 things have been different & look back to successive Xmas days in Plugstreet, Sailly-Lys and Arques. Now comes Xmas near Lille.

We have had a more or less eventful day. First of all we had a full marching order parade. Then we had a kit inspection. We had a marching—order inspection last Sunday & were told to get our equipment scrubbed as regards webbing part, and the leather work greased. It was the first time many of us

<div align="center">Cont . . .</div>

Lille — Le nouveau Théâtre et la nouvelle Bourse.

2/—22/12/18

had scrubbed own equipt.

I'm not feeling quite fit lately. Have a cough that is troublesome at times. And the job isn't a very energetic or pleasing one & when one hasn't much doing even the jobs that turn up don't get done so well. Still I am sticking it now as hope for New Year is high.

We are fairly busy just now o'nights, getting a few concerted items ready for Xmas night. I am not really keen on it but feel that Xmas Day should be made as cheery as possible.

The last 2 weeks we have had a mid-week lorry running to Lille after

3/—22/12/18

tea. The first week I went to the theatre (shown in 2nd card but much more imposing than the card suggests). Last week 3 of us had a wander round the streets & about 7.30 we were very hungry. Couldn't find any restaurants or places for a feed so we tried 2 or 3 confectioners' shops. The prices of cakes etc were so extortionate that we walked out of the first 2 without buying. At the 3rd one, not far from the x on this photo we went in & I enquired the price, of so many things that I had to come out laughing, so did the 2nd one of the party. The 3rd had to save his face by buying some chocolate. It was a farce.

You'll notice 2 of the cards show different aspects of the Grand Place (statue in each photo), & 2 of them show the new Bourse in part or entirety.

Cheerio, best love from

Leo.

LA CITADELLE, LILLE

4/—22/12/18

P.S.

Since writing I have recd. your letter with P.O. Thank you very much.

Just a word.

Do not address any letters to me at Annappes. My address is <u>as before.</u> Will you return this to Dad (361)? The <u>place</u> must not figure in my postal address

Leo

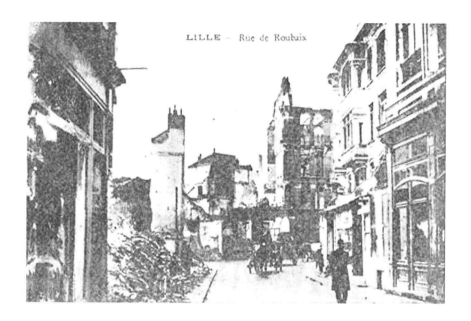

LILLE – Rue de Roubaix

Xmas Day. 1918

My darling lassie,

I can write of Xmas Day 1918 that the Company had a jolly fine time & that everything passed off finely. I'm glad I gave up the Boulogne idea as I was the responsible party in certain of the concert arrangements.
Well, I'll just give our programme of the day.

7-30 Breakfast
10-00 Football match
1pm Dinner
Tea
Concert
Sandwiches & drink

Parcel arrvd. on 24th

I shall write a long letter soon.
Cheerio & very best love.

Leo

Following is a Christmas card from Hilda (Anne–Marie's sister) who is mentioned in several letters.

<u>France Xmas 1918</u>

To my dear brothers Phil & Jon
With all Good Wishes for a
Happy Xmas
From
<u>Hilda</u>

Namur-Citadelle Confluent de Sambre et Meuse

Friday, 27th December 1918

My dear lassie,

How do you like this card of Namur? Isn't it a good one? I got it on account of the view & the war history of Namur—it fell very quickly as a fortified town. The second card (of Charleroi) is of a town not far from Namur.

Well, I got the photos tonight of our concert party. It was unfortunate that two of the party (Cpl. Little & Sapper Dixon) couldn't manage to get there, but any-how we have had a meeting tonight among ourselves & all being well we shall try to have another concert in 3 weeks time. That is the idea at present. Our more or less informal one,

Charlerol Ecole Moyenne de l'état.

2/—27/12/18

(In the sense of the limited nums and properties) went down so well that we can "do" a good one later.

I hope you had as enjoyable a Christmas Day as we had. Most of the fellows were sober too—which is different to one or two I've seen. As a consequence every thing was appreciated.

We are getting more & more wound up in the tangled skein of demobilisation, but I believe it won't be long now. I have great hopes.

Cheerio & very best love,

Leo

Sunday, 29th December 1918

My sweetheart,

I enclose a Christmas card from Norman Carruthers. As novel a one as I've ever seen and a bon souvenir.

I was on duty this morning & had a busy time too. Owing to being on duty I couldn't go with our team to see their 1st round in our Army Cup.

There'll be some excitement in Blighty over the election results I should say. According to what we heard this morn. Messrs. Asquith, McKenna & Simon are not in. The paper will be round in the morning.

It has seemed rather

LILLE — Boulevard de la Liberté (Belle Jardinière)

2/–29/12/18

Funny not having a letter or anything from 97. Perhaps it has got lost or delayed, not that I complain of my Xmas mail–I've heard from your dear self, dad(361), Alan, Pontefract, & Hilda.

Well, I am sure you will be delighted to hear that one or two of our men are on their way home & that 2 or 3 more are almost due. In connection with this I have sent my letter from Mr. Parkins to the B'ham Local Advisory Committee for endorsement. If it is sent to you please send it out again to me. I expect it will come direct to me. I do not want to raise false hopes

3/—29-12-18

but if the letter comes back endorsed I shall put it in to the O.C. & I think I stand an excellent chance of fairly quick movement, <u>possibly</u> within the 2 or 3 weeks after the letter back.

And now—it is the <u>29</u>th. I wonder if I dare prophesy (I've nothing definite to work on) that I may be with you on the next 29th. I haven't had a <u>single</u> 29th with you since 1915—perhaps the New Year will atone by giving us all its 29's.

Cheerio my darling,

Your loving chum.

Leo

Tuesday 31ˢᵗ December 1918

My dear lassie

The year closes. I've seen more of France this year than any other, being located
at different periods at Wallon Cappel, St. Jan's Cappel, Calais, Lumbres, Rouen,
Seenvoorde, Dennebroeucq, St. Venant & Annappes (Lille), and in Belgium at
Ouderdom & Busseboom (7 days & nights). It looks as tho' 1919 will break my
record of being stationed in France or Belgium at different times 1915-16-17-18.
I think I shall only be located in France this next year, before I leave for Blighty.
Any how if it is my "snap" card—bon! Two or 3 have gone this week & I am now
sweating on my letter arriving with the Local Advisory Committee's endorsement.

31/12/18–2

I think that I stand a chance for Jany. if it soon arrives.
Meanwhile, the very best love & good, cheery wishes for an early 1919 reunion.

Your loving husband

Leo

To Marie
from Leo

1919

Lille Le Palais Rameau.

Wed. New Years Day 1919

Dear Father & Mother,

The year opens. I wonder what will have happened by say Jan 31st! My hopes for
this month will remain slender until I get my letter back from the Local Advisory
Committee.
Re. dads' of 23rd. You'd be glad to learn that we had a very enjoyable Xmas
Day, thanks to organisation & work of a few. You refer to Alan saying that my
collection of souvenirs is a good one. Anything in particular—I hardly know what
he refers to. By the way Annappes is pronounced as if there was one "n" only.

The Lac may be more easily explained if compared to the American draft board.

Lille La statue Pasteur.

2/–1/1/1919

By the way don't forget to address to me at 351 & Cat BEF, France <u>omitting Annappes & c.</u>

The results of the election were surprising in a way. We didn't expect many opposition Liberals but we thought Labour would do better. Glad Kneeshaw was knocked out.

Sport recreation is going stronger now; a result of Army lead and action. Our team is doing well (Soccer) not beaten in 12 matches to date. 2nd round of Army Cup (our Army) on Friday. Our team is lacking several A1 players (on leave) but has unearthed useful subs.

Cheerio,
Love,
Leo

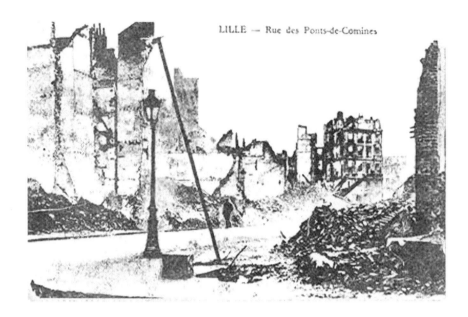

LILLE — Rue des Ponts-de-Comines

Thurs. 2nd January 1919

My darling lassie,

Censorship restrictions have been still further removed & men can now seal all
envelopes provided the name of the man is on the left hand bottom corner. So
this is my first to you & I think you might keep it for a souvenir.

Today I have been preparing a demobilisation affair with the Sergt Major. Am
down on the list among the long-service men (over 3 years abroad) so, as there are
not too many for our particular area there may be a move soon.

Your letter of Xmas Day arrived today. The mails have been very backward (contd)

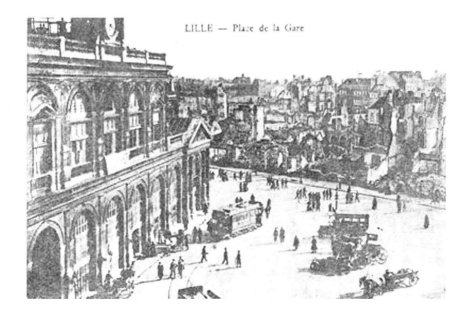

LILLE — Place de la Gare

2/—2/1/19

lately. I quite agree with you about my photo. I think the light was partly
responsible but I certainly wasn't up to the mark. I feel altogether fitter now
though as long as I'm in this office I shall be fed up.

Glad to know you had such a fine Xmas dinner. It was very good of Uncle Ben.
My dear—will you please make a small list of any suggestions you want to make
when I come home. I am beginning to look forward to it all now.

Cheerio my little girl

Your loving chum

Leo

Thurs 2nd January 1919

My dear Marie,

Today has been a mixture of emotions. First of all pleasure, then disappointment, then jollity, then calm. It happened thus. A clear cold day. Looking forward to footer match. Asked to stand down for another player. Protested as the circumstances were not fair to me. Stood down under pressure—and also intimated I had finished as football committeeman. Jolly fun before footer match. Afterwards (tea & onwards) reading or writing. Very disappointed I was on standing down & I expressed my feelings suitably.
Hoping for further allotments this week.

Cheerio. Love

Leo

Sunday 5th January 1919

My dear chummie,

I chose this card, on account of its prettiness, out of a lot today in a shop. Isn't it a fine study? The little girl is charming—in fact they both are.

Glad you liked the photo of the concert troupe. It was a good one too. Since then we have had two jolly evenings, several of the concert party going to a civi. house where there is a piano.

At last a decent start will be made tomorrow on demobln. here. 4 men are going & 2 the day (contd)

2-5/1/19

after. In the first place there were 11 to go tomorrow but this was cancelled
in part. A B'ham man & Marshall (<u>Warwick</u>) go in the 4 tomorrow. As you
may guess, I am beginning to sweat; there are only 2 or 3 in front of me in our
Dispersal area after tomorrow. Percy (having Handsworth (in Staffs) as home
address) goes to another Dispersal area. So we shall not leave the Army together.
In addition of course he is waiting news re his application for Special Leave.
Cheerio my darling. I do not think it will (contd)

3-5/1/19

be long now. I do not know how I shall be placed for pay so perhaps you would send me 10/= (shillings) or £1 by <u>return post Registered Letter.</u> This in case of going before next payday (2 weeks ahead). By the way I am hoping to send books tomorrow.

Cheerio—all my dearest love to you

Your loving Sweetheart

Leo

Nieuport
Barques à quai sur l'Yser

Tuesday 7th January 1919

My darling lassie,

Just a few lines. You will notice thes cards are of Nieuport; another town (or place) for your series.

Percy has gone on special leave. He is going to see to our "Guaranteed letter of employment" business. Meanwhile 3 went yesterday (out of 4) for Chisledon (Wilts), one today (out of 2). That (Chisledon) is my dispersal station in Blighty. 12 of our fellows leave tomorrow (2 for C.) several the day after (2 for C.) and if we get an allotment for Friday, allowing 2 for Chisledon (contd)

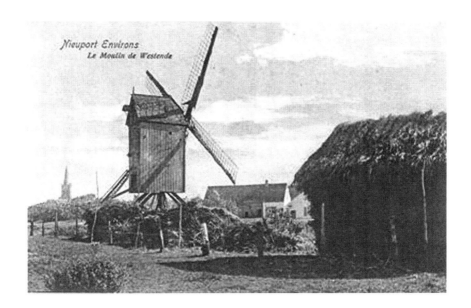

Nieuport Environs
Le Moulin de Westende

2-7/1/19

I shall be one of the two all being well. Will write tomorrow.

I sent some Pelman books to you today. Keep them put by, please. I may send another parcel of books etc. Meanwhile the Regd. letter with P.O. will be retd. to you if I happen to leave before it arrives here.

Of course I am sweating on that telegram tomorrow, allotting 2 for Friday. What a lot it does mean. Anyhow I do not think it will be long.

Cheerio my darling

Your Leo

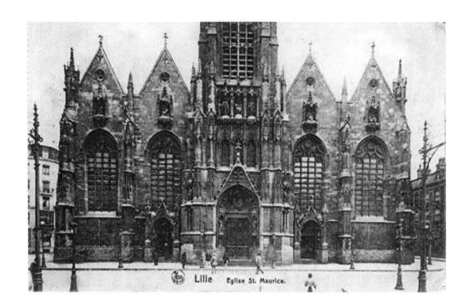

Lille Église St. Maurice.

Wed. 8th January. 1919.

My dear Marie,

As promised I keep you in touch with events. Today our allotment for Friday
arrived but I shall be unlucky as the one vacancy for Chisledon is for a guaranteed
letter man—and I'm waiting for my letter from Brum. The worst of it is that I
heard the allotments were stopping from Friday onwards. Whether this is true or
not I can't say—I do not think it is for more than a few days from a further letter
we have received. At any rate (and I'm rather disappointed for a Brum fellow with
the same qualifs. as myself in every way—service abroad & married) goes tomorrow
I feel that God's Hand is in it and I am just going to keep a cheery face. I know
you will feel rather sore—perhaps tomorrow WILL after all continue an allotment
for Saturday—but just imagine my feelings when I took the message down and
knew I hadn't clicked. (cont'd)

2-8/1/1919.

In any case I shall probably be here now when your Regd. letter arrives and I want
to get away a few more things for myself, in addition to some I'm clearing away
to Walter Wilton, my London chum. Now I feel that I must ask you to KEEP A
GOOD HEART. I will keep you supplied with news. Some of the lads who left
here for demobilisation had not got any further than a few miles from here in 4
or 5 days. So when I do leave here I may be hanging about in camps out here for a
few days. The thing is to get a start from here.

Had another nice card or two from Norman Carruthers today. He is in Cologne
still. Had a letter from Alan yesterday and you letter of the 3rd confirms his home
arrival particulars. So he's beaten Eric and I. Who's next?

Cheerio darling.

Best love.

Leo.

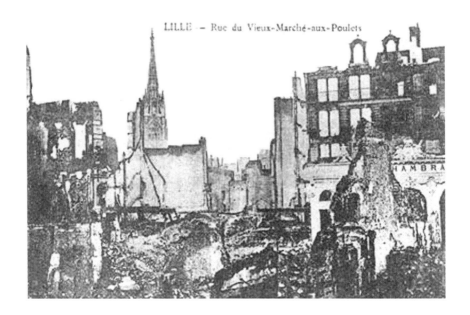

LILLE – Rue du Vieux-Marché-aux-Poulets

Sunday 12ᵗʰ January 1919

My dearest chummie,

I intend to keep in touch with you fairly closely as regards news. Nothing doing today as far as I know, but I hope for tomorrow. I sent a second parcel of books this morning.

Cheerio dear sweetheart.

Keep hope for the 23ʳᵈ & 29ᵗʰ yet.

Yours ever

Leo

Lille La Porte de Paris.

Monday 13th January 1919

My dear lassie,

Another day has gone and nothing doing as yet. I have hopes of this week—now it remains to be seen if hopes will turn up trumps. The waiting is wearisome when one is impatient of each 24 hours.

Meanwhile I'm just sticking steadily at my studies and making headway too.

Yours of 7th to hand today. You rather excite my interest in saying you are preparing for my homecoming may it be <u>very</u> soon. <u>I'm</u> ready any time: it's only the Army that isn't—and there y'are. Alan writes a cheery letter recd. today.

Best love

Leo

Friday 17th January 1919

My sweetheart,

By now it is almost impossible for me to get home for your birthday. We have nothing through today up to say 6pm. And if it comes through tomorrow & I click for going it would mean I shouldn't go before Sunday or Monday from here. And as I hear that some of our fellows are still at the first stage, not far from here (& they left 8 or 9 days ago) they haven't gained much so far. They are having an easy time but the waiting must be tedious.

Just a word or two. In writing to me, do <u>not</u> enclose a letter with any papers by any chance. Papers (cont)

might not get back to 361. Letters & papers are sent back to the home address but the Post Office might refuse to be troubled with the papers.

These views are of a place near where I landed back from my last leave. It was in this village that I saw the service being held in a roofless (as regards the nave) church.

The mail has been very irregular lately. The latest one I have from you is dated 7th & arrived on the 13th, 4 days ago!! No bon, eh?

Cheerio my darling. Ever <u>yours</u> and hoping that I'll soon give you a good hug & some real kisses.

Your lover

Leo.

131 LILLE. — Le Palais Rameau. — Rameau Palace. — LL.

Sunday 19th January 1919

My darling lassie,

Just a few lines. Nothing through so far & the fellows are beginning to show signs of a fun spirit. And no wonder for we are disgusted with demobln. figures <u>on paper</u>. What we want are actual facts, not figures.

Have been to the Y.M. service in Lille tonight very hearty singing.

Leo

To my darling wife
With best love &
Happy returns.
From Leo
France 20/1/19

An undated response from Anne Marie

To my dear husband
From your wife
Yours Ever.
Annie.

Tuesday 21/1/19 On active service

Dear lassie,

Nothing doing as yet but I think we shall click here next week—Monday is mentioned. Will give details later.

Cheerio, Leo

101 LILLE. — L'Église Saint-Maurice. — St. Maurice church. — i

Wed 22ⁿᵈ January 1919

My sweetheart,

I had hopes of being at home for tomorrow but you'll know I'll think of you then. Let us hope that by this time next week I'll be on the way.

I shall prepare the readings for Feby. & may enclose them with this card. Otherwise I'll send them tomorrow.

My sweet little girl.

All my love & good wishes & high hopes

Your lover. Leo

1 LILLE. — Vue panoramique de la Rue Nationale. — National street general view. — LL.

24th January 1919

Dear chummie,

Just a line or two to say—still sweating on next week's news.
Cheerio
Leo

Satdy. 25th January 1919

Dear lassie,

Hopes for next week's news. I think there will be something doing.
Meanwhile I haven't had a letter from since the one dated 14th.
Snow this morning—the first since last winter. Not above an inch or two.
Cheerio. Love,
Leo.

118 LILLE. — Le Jardin Vauban. — La Grotte et le Lac.
Vauban's garden. — The cave and the lake. — LL.

Tuesday 28th January 1919.

My sweetheart,

The first item is that we have 3 men down to leave here on Satdy. One is for Chisledon—but not a Pivotal man. I hear that it may mean more a day or two later.

The next new is that leave has stopped tonight—on account of demobln. it is said. If it means that demob. is <u>really</u> <u>going</u> to start well & good. At any rate for the time being it cuts out the (here Corpl is crossed out) N.C.O. (who I spoke of in the "race") for the time being.

Meanwhile I'm on with my 9th Pelman sheet—(contd)

2-28/1/19

& I'm keeping up with my French steadily going—I have been for some time.
Moreover for the past 3 weeks I've been one of the football committee of four. As
we have Sunday & Wedy. matches there is a certain amount to do, marking pitch,
arranging matches etc. & selecting our team. And as I'm doing a little boxing,
with a good boxer in the Coy. I'm doing my best to relieve the tedium of waiting.
Have you received the Pelman books? Let me know please.

Cheerio darling. 29th tomorrow but never mind.
Your lover, Leo

Wed. 29th January 1919

Dear lassie

Many rumours floating about re demobln. & I think one of them is true.
Meanwhile today is the 29th! We had hopes but we needn't give 'em up for next
weeks or two's allotments. Cheerio, Love, Leo.
Spr. L. Sidebottom

Thurs. 30th January 1919

My dear little girl,

I am finding more to do just at present, o'nights, as I am putting in about half
an hour, after tea with a fellow who is a strongly built fellow and has a decent
knowledge of scientific boxing. He says I am picking it up well & as for myself I
am jolly pleased to get such a fine exercise. Proper ring work we are observing &
I'm feeling at home in the "gloves".

A streak of hope begins to illumine our demobln. prospects. A couple of days ago
we had an allotment of 3 for next Satdy & now today we have 2 more men for
Monday. As one of these latter 2 is a long service (but not Chisledon) I think we
may (contd)

2-30/1/19

stand a chance in next week. Of course I'm sweating pretty badly as <u>the</u> <u>N.C.O.'s</u> leave is drawing nearer.

I am nicely on with my next Pelman sheet & hope to finish it by the end of the week. Meanwhile I've managed a little novel reading of late. At present I'm on with "The Pennycomequicks" by S.J. Baring-Gould—you should read it.

Thank you for "John Bull" & yours of 23rd. I know you are hungry for me—and you know how I feel. Pleased to hear you have finished your big piece of crocheting.

Do you know dear I haven't heard from 97 since sometime before Xmas.

My sweetheart—cheerio & very best love & hope

Leo.

Monday 3rd February 1919

Dearest Lassie,

Today I had quite a mail. Pelman sheet (97%marks), letters from Percy, Tangyes guaranteed letter from <u>Handsworth</u> <u>Committee,</u> letter from Harold Sheppard and John Bull & a letter from your dear self. So my letter has turned up at last—it is a fourth application by Tangyes & 3 have therefore been hung up. Percy tells me he is starting in his old Dept. on Febry. 1st at his old salary plus work bonus & increases to staff. So that is O.K. for the present. Meanwhile there are one or two (cont'd)

(0) LILLE. — Le Monument de Desrousseaux.
Desrousseaux memorial. — LL.

2-3/2/19

new factors in the Demobln. scheme, men enlisting in 1916 & after are, with certain exceptions, not to be demobilized. It affects the 2^{nd} man in the race I spoke of. As for the N.C.O. I spoke of he is due for on Wedy. or Thursday. No further news today. I am writing Percy tonight twitting him that he isn't now in a position to get a new jacket & pair of boots for now't as I have done tonight. Have sewed my 4 blue chevrons on & we are all buying 1914-15 star ribbons (those that are entitled to them—I am.)

Well now chummie I am very pleased at my Pelman success. Hope to post another sheet tomorrow.

Very best love, Leo.

32 LILLE. — La Gare. — The station — LL.

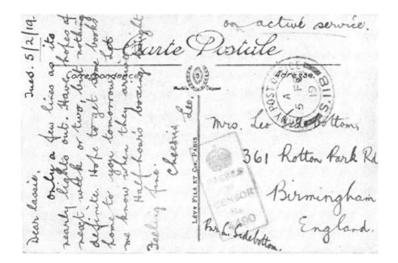

Tues. 5th February 1919.

Dear lassie,

Only a few lines as it's nearly lights out. Have hopes of next week or two, but
nothing definite. Hope to get some books home to you tomorrow. Let me know
when they arrive.
Half hour's boxing tonight. Feeling fine.

Cheerio, Leo.

Sat. 8th February 1919

My dear sweetheart,

As I anticipated we are beginning to get men away now. 4 are due to go on Monday and another seven on Thursday. I will let you know well ahead when my time comes, provided I am able. Meanwhile I'm posting 9th Pelman sheet tomorrow. I am also getting a good amount of French conversation lately in addition to visits to houses (to take or get my washing) I am in request whenever there is a case of French people dealing with us (very often of late).
This photo is of a fine boulevard. It is the Lille end of the main Lille—Roubaix—Tourcoing road.
Hope to get a parcel away tomorrow to you.

Love from Leo.

Sunday, 9th February 1919

My sweetheart,

I have just come in from an hour's walk <u>on my own.</u> I wish you had your arm through mine. It would have been just delicious. The roads are slippery in places but there is a bright moon & twinkling stars & the air is cold and exhilarating. Practically no wind or it would be piercing. At one place I stood still for a moment or two. There was an absolute silence except for the slight rustling of some (cont'd)

68 LILLE. — La Faculté de Droit. — The Faculty of Law. — LL.

2-9/2/1919

dead leaves on hedge & the faint faint "chug-chug" of an engine supplying electric light. My thoughts turned to you—it was about 7pm. I pictured you in church—and at home if not at church. The thought came to me that at present we are both of us leading a life that is incomplete—and in each case the life would be complete with the presence of the other. No doubt we often think these things but rarely put them on paper.

I got a parcel away to you today. Hope it arrives safely.

Cheerio my darling

Your loving husband Leo.

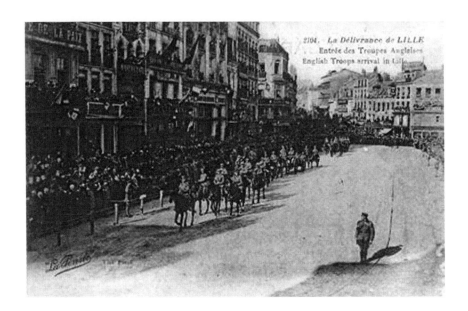

La Délivrance de LILLE
Entrée des Troupes Anglaises
English Troops arrival in Lill

Tues. 11th February 1919

My sweet lassie,

Friday is St. Valentine's Day I believe. And so I nipped an opportunity tonight of a quick trip (on our motor car) to Lille & back. I didn't manage to get the little type of spoon I wanted but the one I'm sending you by registered post tomorrow morning is neat & artistic & good silver. It will complete your six. I didn't feel much like walking to Lille on Sunday night so it was quite lucky that one of our officers was going to Lille camp tonight. My darling this little present is in no way intended to take the place of the ring I am going to bring you for your birthday,

Cheerio my darling

Leo

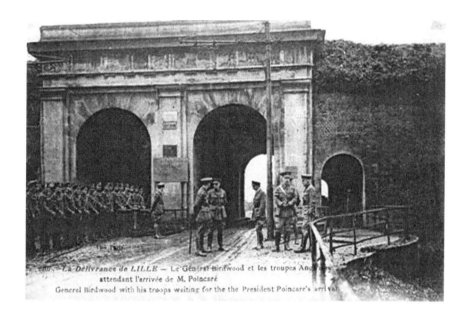

La Délivrance de LILLE — Le Général Birdwood et les troupes Ang...
attendant l'arrivée de M. Poincaré
General Birdwood with his troops waiting for the the President Poincaré's arrival

Friday, 14th February 1919

Dear little girl,

The weather is turning from frosts to rain. It has been milder today than the past 3 weeks or so.

I think you'll like this series of cards. This one shows one of a series of "Portes" or gates, over which the railway runs. They are all round the city and all connected by a big embankment. I believe, though am not quite sure, that this is the gate I first entered Lille by—either Porte de Douai or Porte de Canteleu.

We are steadily getting men away now. At present I'm busy, especially at weekends. Today I have been on one Return most of the day—one requiring careful watching in the way of figures and particulars.

Haven't had much boxing lately as the fellow I was trying 'em on with has "gone sick" for past week.

Today is Friday, St Valentine's Day.

All my love,

Leo.

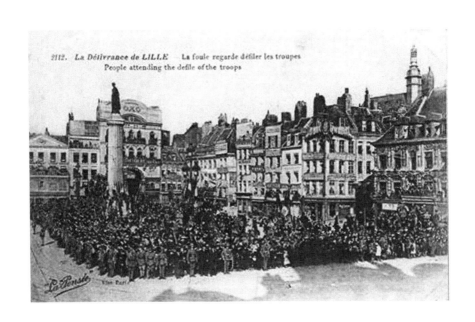

2112. La Délivrance de LILLE La foule regarde défiler les troupes
People attending the defile of the troops

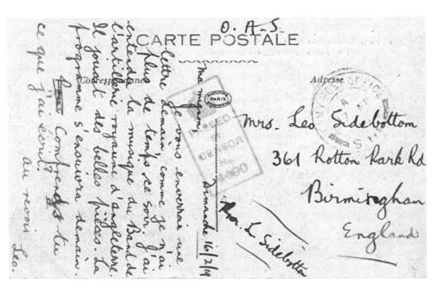

Dimanche 16/2/1919

Ma mignon,

Je vous enverrai une lettre demain, comme je n'ai plus de temps ce soir. J'ai entendu la musique du Band de l'artillerie royaume d'Angleterre. Il jouait des belles pieces. La programme s'ensuivra demain.

Comprends tu ce que j'ai ecrit?

Au revoir

Leo.

My sweet,

I will send you a letter tomorrow, as I do not have any more time tonight. I listened to the Band of the Royal English Artillery. They played some pretty pieces. The programme will follow tomorrow.

Do you understand what I have written?

Till I see you again

Leo

sois. *Lille. Le Château Rihourd.*

Tues. 18th February 1919

My dear lassie,

Since last week the weather has completely changed & it is now quite mild. In consequence the roads are muddy & sticky.

I have some decent news for you. By the end of this month we shall have got away a lot of men & will be more or less shaping to leave the place. So I think the time can be measured now by a very few weeks.

I am starting boxing again tonight as my pal is alright again. Am feeling fit & well myself.

Expect there will be a letter tomorrow from you so I'll close for tonight

Ever yours

Leo.

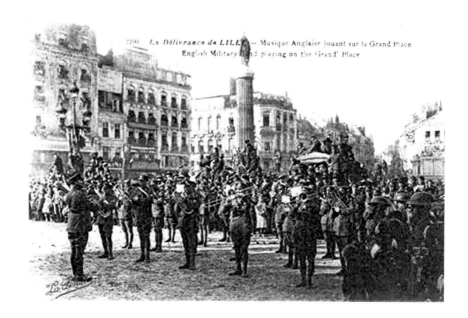

La Délivrance de LILLE — Musique Anglaise jouant sur la Grand Place
English Military Band playing on the Grand' Place

Friday 21st February 1919

My sweetheart,

Thanks for your letter of the 17th. Very pleased to hear that parcel of books
have arrived. There is only another one now which I haven't yet heard you have
received. I may be sending another one on Sunday. By the way I have a little trip
in prospect for Sunday aft'n. A trip by electric train to Roubaix. If I manage it &
see any silver spoons of Roubaix I'll get one to make up six silver as I know you
haven't one of that town. Meanwhile keep up the preparation for my homecoming
& and get yourself into the best trim possible as I'm getting myself as I can in all
ways.

Ever your sweetheart, chum & husband,

Leo

Sunday 23rd February 1919.

My darling lassie,

It is 8-15pm & I've been back half an hour. I have had an afternoon since 3pm full of enjoyment I set out at 3pm for the main Roubaix-Lille road. It is an exact hour's walk for me within a minute. Caught tram (electric) & a quarter of an hour later I was in Roubaix (centre). It is a delightful place in my opinion. The usual big square (Grand' Place) is a splendid one. On one side if it is the Town Hall. This photo does not do it justice either in apparent size or (cont'd)

4 ROUBAIX. — La Grande Place. — The great Square — LL.

2-23/2/1919

grandeur. On the other side (right opposite the Town Hall) is the church shown in this photo. Inside the church one becomes aware that the width seems greater than the length.

<u>Of</u> <u>course</u> I thought of you. I stood in the big square admiring the town hall, at 4-30 & I <u>wished</u> I'd had you there. Dearest, all being well we <u>must</u> have a trip round Northern France, sometime.

Well & after some tea I had a look round for a spoon of Roubaix—and got a silver one, almost at once. I shall probably send it on Tuesday by Regd. post. It will make your set of silver ones up to 6.

Your lover

Leo.

Mon. 24th February 1919

My dearest,

I have tonight packed two parcels, to leave here in the morn. One is the little Roubaix spoon, & the other is one containing football togs etc. etc. The first I shall send by Regd. Post

Well the C.S.M. told me today that I am on the cadre strength of the Coy. Judging by present news it doesn't mean very long now, especially as we are sending away a very big number of men—so many that by the end of the week we'll be a very insignificant unit. So that I think the next week or two will see things humming. Let me know when parcels arrive. By the way my 9th Pelman sheet came back on Satdy.—100% marks.

Cheerio. Best love,

Leo.

Wedy. 26th February 1919

My darling,

The O.C. only ret. late today & as I'm going out tonight with some of the boys I shall not be seeing him until the morning. I'm ready for him. 3 weeks is the date given at present in which the Coy. will be in Blighty but I'm going to try for something better tomorrow. Meanwhile I hear those retained pro. tem. Are entitled to 10/6d week extra—latest order out today but as I haven't actually read the order (half day today & out of the office) I am not sure on the point.

Now your letter of 21st arrived today. Glad to hear you received the football togs which I sent. Don't get trying them on y'know!

I do not doubt my (cont'd)

2-26/2/1919

ability to make good, once I get to Tangyes.

If both dad & Alan are inclined to think nothing of Pelmanism or to laugh at it—what odds. It is a <u>positive</u> education to me and I am absolutely <u>convinced</u> of its value. And as I'm studying it I've <u>the</u> chance of judging.

Hope to go to Roubaix again on Sunday.

Cheerio my darling,

Your lover

Leo

I walked up the station street shown in photo on Sunday & had tea at a shop just outside left side of photo.

16 LILLE. — Le Monument de Pasteur. — Pasteur's memorial. — 1

Thurs. 27th February 1919

My dear lassie,

Today I approached the C.S.M. to see the O.C. about my demobln. He told me a Coy. Order was going to be made (and sat down there & then & wrote it out for me to run out on typewriter) showing men on cadre strength. Any man is to have the opportunity to see the O.C. re demobln and so as it will be read out officially tonight, I shall go in tomorrow. As I'm doing work constantly for the O.C. he knows me well enough. Meanwhile, dearest, the news is that the Coy. Will probably be moving for Blighty about 15th March or so, so even if unsuccessful it won't be long; and if successful I may come very soon. By the way, if retained for the cadre (i.e. unsuccessful) & probably moving about 15th March I am entitled to 10/6d week bonus from Feby 1st, 1919 as a cadre (cont'd)

223

Notre-Dame de la Trellie church. — LL.

2-27/2/1918

member. So in that case it would already mean £2-2-0 more to my credit.
Yours of 19th. I am so glad to hear you have got some coal. Delighted to hear
of your eiderdown quilt purchase—evidently you are hoping to share with me
soon—and so am I. Glad you like the "Pennycomequicks."
My old chum Tommy Gardner goes tomorrow—another Chatham and B.E.F. pal.
He & Percy & I were a trio at Chatham. I hope to follow him soon. Yours of 21st.
You will find some Tyneside music in that parcel I sent this week. I want you to
keep 'em on one side till I come, so that I shall introduce them with the dialect.
Am still swotting the book.

Cheerio my darling, Leo.

94 ROUBAIX. — L Egine Saint-Martin. — St-Martin Church. — LL

28th February 1919

Dear lassie,

Am waiting one or two others who expect to see O.C. tomorrow re demobln. Tom Gardner went today. Somehow I fancy we shall be away from here in 2/3 weeks. Leo

9·40pm

Sun. 2nd March 1919

Dear Swetheart,

Will write long letter tomorrow. Have just got in from trip to
Roubaix–Tourcoing–Lille & as I've bed to put down etc. there isn't time for a
letter

Love from

Leo

Tues. 4th March 1919.

Dear lassie o'mine,

My chance of being taken off cadre strength is not worth considering. However the O.C. has promised to write tonight to Tangyes explaining the delay of a few extra weeks, which was my idea & will be a point in my favour at Tangyes as I know he will put in a very good word for me. Meanwhile I hear that demobln. has stopped in this Army, which means that I should not have got away at present, had I been taken off cadre & should also have been ineligible for 10/6d week bonus of cadre men. The probability is that when it reopens again it will mean a move for us. Dearest—use the present time for getting mind, heart, bowels (I use word advisedly) into perfect daily order. It won't be long now.

Your lover

Leo.

TOURCOING. La Place de la République et l'Église Saint-Christophe.
The Square of the Republic and the Saint-Christopher Church. — LL.

Wed. 5th March 1919

My dear lassie,

This afternoon I have had a most interesting ride on our light car. 2 of us went
with the S.M. to try & salve some small but valuable parts of engines buried by
our boys in the push last April. The hun evidently didn't suspect anything for we
got them all right. But that is not my news. We had to pass through Armentieres.
The whole place wears a changed aspect. One cannot recognise former
places—they are in ruins, of the town hall there is a heap of rubbish in the place
of the clock tower. It is very sad & desolate. After Armentieres came Pont Nieppe.
The big factory where Alan bathed by the river is in ruins & heaps of dust. After
salving parts we went on through Steenwerck. Houses (cont'd)

5/3/1919—2

smashed & battered but a fair number of walls standing. Then to Bailleul. I had
seen a photo in the "Observer" some ago of the ruins of this town but almost
believed it faked. But I was staggered today especially by the "Grand' Place" (only a
name) you have photos of Town Hall. Well it looks like this now.

The 2 standing portions are about 15 foot high & 3 to 4 feet wide (front). Most
of the heaps are mere <u>dust.</u> Absolutely pulverised. And the strangest thing of
all is to see the horizon so low. Instead of standing in the centre & looking
over the houses at about this angle:—∠ it is now like this ———. We came
back through Nieppe. Turn up my diary for August 1916 & I think you'll find a
reference to spending time (one Sunday afternoon) in cellars of RAMC opposite
church. Well ther is no "opposite church" now & little opposite anything!! Then
thro' Pont Nieppe & Armentieres to Lille (cont'd)

25 TOURCOING. — L'Hôtel de Ville. — The Town-Hall. — L.L.

5/3/1919—3

& "home." I was glad I managed to see the places again that once stood for home to me, but it is a tangle of devastation & rubbish. And yet civilians are beginning to work back again!!

Haven't I had some tripping about lately?

I believe I am about first on the leave list, but don't know whether I'll get leave just yet. Should like it really, because I could get my own property home & then come back & probably go off on demob. soon after.

Enclose you'll find letter copy which each of us is receiving. It will be a souvenir worth keeping

Your loving chum

Leo

Dimanche

Le 9 Mars, 1919

Ma mignon,

Je vais vous envoyer plus de nouvelles demain soir. Je suis toujuours en bonne
sante, ainsi que j'espere de rester meme. Il fait beau temps aujourdhui. Si
je recevais des article que j'attends, je vous enverrai un pacquett la semaine
prochaine.
Tous mes baiser a toi
Leo

My sweet,
I will send you more news tomorrow evening. I am always in good health, and
I hope to stay that way. The weather is good today. If I receive the things I am
waiting for I will send you a package next week.
All my kisses to you
Leo

Satdy.8th March 1919

9-30pm

Dearest Marie,

The fear which haunted me yesterday has not been so strong today though yours of 1st, arriving today makes me feel concerned, as you had caught a cold in your back. I am hoping it has gone by this time. Pleased to hear the silver spoon arrived O.K. also parcel of football togs. I paid 3/10d for the two pairs of "nighties" sent. Not a bad bargain, eh?

Glad to know the Regd. letter (containing letter only) arrived O.K. By the way the O.C. has written to Tangyes explaining my delay.

I have been to Lille to hear RE (Royal Engineers) tonight (programme enclosed). Very enjoyable. You'll notice 2 items played by RA (Royal Artillery) band. Tonight, as an encore, a jazz piece was played. It was funny. Lively music & in the piece various squeaky & other noises introduced.

Love from Leo.

Mon. 10th March 1919

My dearest,

I am writing now for a letter. Haven't had one since Satdy. morn. and of course I'm just wondering how you are, after last Friday's thought.

On the 16th I shall have been back 5 months & I may get leave then—it all depends. I hope in one way that it comes off as I should probably get back from it just nicely in time for any move on the part of the Company. We are still busy packing and straightening up—I do not think it is more than a matter of a few weeks. If I chance my arm & say probably 4 to 5 weeks. You

(cont'd)

Card note: King Albert was hugely popular in France (and Britain and the US) due to his refusal to bow to political pressure to surrender in the early stages of the war, and his determination to remain in Belgium rather than flee.

10/3/1919—2

must not take it as absolutely definite. It is mainly based on the letter I spoke of to Tangyes Ltd. Orders etc. & general items coming thro' suggest towards the end of March or in April. I believe &_hope_ that you will accept this news in the best way—a hopeful one.

I am getting some piano practice ready for home. The little boy where I bought these cards sends a kiss **X** to which I also add mine.

Cheerio & very best of love,
Unsigned.

Card note: Marshall (senior to Field Marshall) Foch was the overall commander of Allied forces in WWI, much as Eisenhower would be in the latter stages of WWII. He was regarded with almost religious respect by the French, and his only real rival for public affection was Marshall Petain, now remembered mainly as the puppet leader of Vichy France. Foch was dubbed the "Vanquisher" rather than conqueror to emphasise the fact that France only entered the war in response to German aggression.

Following is the letter Leo writes when he finally gets notified of his demobilisation. Hastily written on a scrap of paper.

Thursday 17th April 1919

Today is Good Friday from the church point of view, from mine it is Glorious Friday, for I start tomorrow at midday for Blighty for demobilisation.

Isn't it just great news? Beggard if I quite know how I feel. Certainly are not very excited. I went to Roubaix yesterday afternoon and got the linen—posted it this morning. Then I heard about 9.30am today that my demobilisation was coming through. The sergeant major put me onto the preparing of my own papers at 12 noon when our cyclist on coming back from headquarters told me there was an allotment with my name for tomorrow.

So at last it all seems so strange. It has been just like a queer dream the last few days, in fact it's a good job I keep a diary and record of each days doings. But, please God I shall soon be with you. Oh chummie, mere words do not express this satisfaction at closing a period of 41 months on Saturday next.

I shall not be with you for Easter Day, and it will be lucky if I am home by Tuesday evening, but we shall see. I shall do my best to write or wire my progress, to give you a chance to meet me this time and I think if you're meeting me means that you'll have to cut out the party I feel that you will do it. Only if no news has arrived by the time you have to go to the party, do not stay.

Of course you'll not write anymore to 351Co. They'll be returned if you do.

Two letters of yours arrived this afternoon. Let me say at once that I'll soon prove whether I'm vexed because a soldier pal was with you at the confirmation service. I think I can trust both you & Jo to "carry on" all O.K.

Oh sweetheart, I thrill with delight at the prospect. This time next week—how joyous . . . Your loving husband & chum Leo.

Leo and Annie lived happily into their eighties,
Inseparable to the end.

Lightning Source UK Ltd.
Milton Keynes UK
UKOW04f0312291013

219947UK00002B/90/P